Rembrandt

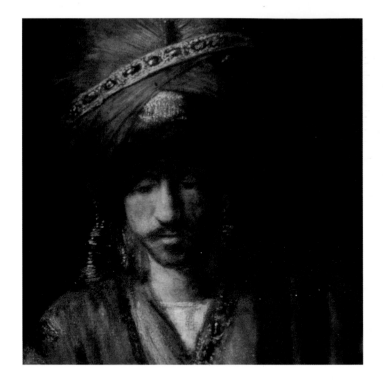

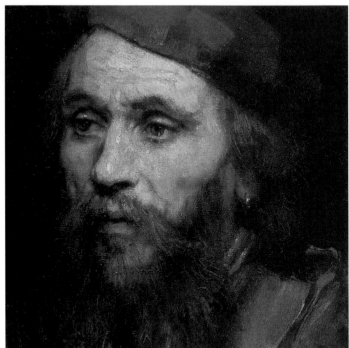

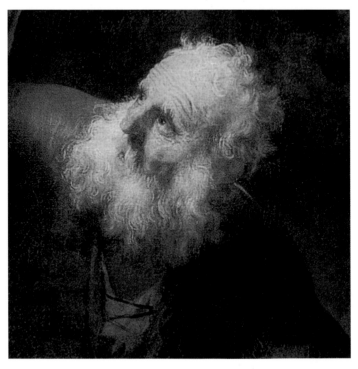

© 2005 Confidential Concepts, worldwide, USA
© 2005 Sirrocco, Londres, (English version)

Published in 2005 by Grange Books an imprint of Grange
Books Plc The Grange Kingsnorth Industrial Estate Hoo, nr
Rochester Kent ME3 9ND
www.Grangebooks.co.uk

ISBN 1 840135 57 3

Printed in China

Rembrandt

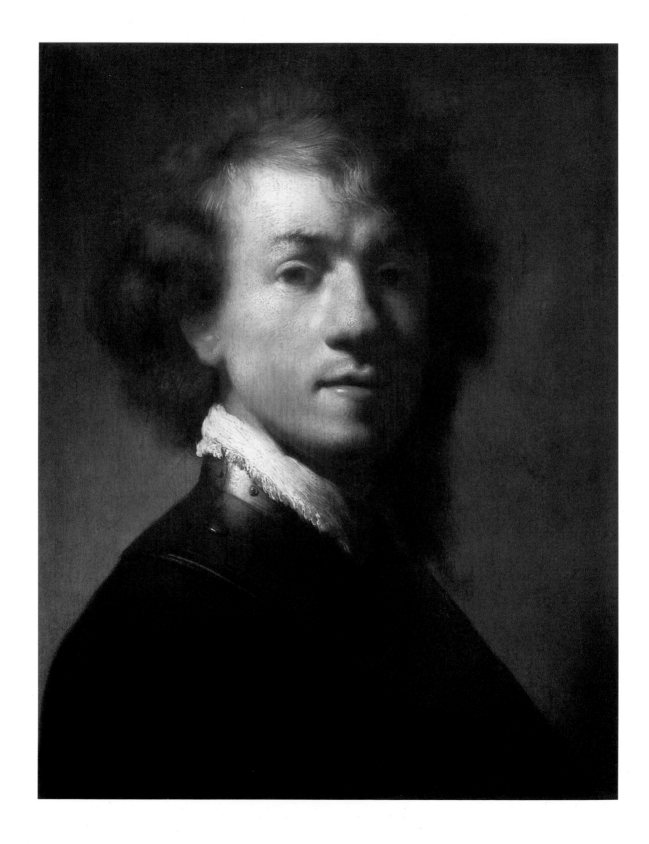

In the days when Dutch merchants traded in the Far East and the Antipodes, a miller named Harmen Gerritszoon van Rijn lived in Leyden. He had eyes only for the son who was born on 15 July, 1606 at the start of a century which promised so much and was so auspicious for men of destiny.

The child was later to be known simply as Rembrandt, his first Christian name. The young Rembrandt soon manifested the artistic skills, which his teachers discerned from his earliest years. After studying the humanities in his home town, the youth who had not yet passed his fourteenth birthday, enrolled at the University claiming to be an accomplished draughtsman.

In 1621, Rembrandt became the pupil of Jacob van Swanenburgh, and completed his studies in the studio of Pieter Lastman, whose paintings of large frescoes of historical scenes instilled in him a love of precision, detail and sumptuous backgrounds of the type in which his master excelled. Rembrandt's official apprenticeship was relatively short. In 1625, the young Rembrandt set himself up in his own studio, ready to fulfil his own ambitions by trying his wings like other young men of his generation whom trade with India had precipitated into a different adventure, seeking to make their fortune. All Rembrandt had were his pencils with which he hoped to earn the comfortable living of which he dreamed and which his father, who died in 1630, had been lucky enough to see emerge from the tip of the paintbrush.

Whilst still studying under Lastman, Rembrandt painted many scenes from the Bible in which certain objects were illuminated with a conventional spirituality, which was often unusual but sincere from a pictorial point of view. He was inspired not so much by mysticism but the special mystery of the biblical story. Details such as the fabric of a headdress or the shadow of a column emerging from the background were highlighted to give emphasis. The painter's own faith made him able to translate the saintliness of the figures to the canvas.

1. *Self-Portrait*, 1629, oil on wood. Mauritshuis, The Hague, Netherlands.

Rembrandt was no longer sacrificing the subject-matter to the theatricality of the masters of his day, Caravaggio and Manfredi, whose work he found trivial. Rembrandt, at the age of twenty, was not the artistic heir of Michelangelo and the mannerists. When he lost himself in the excitement of painting, he was neither consciously a realist nor an expressionist. He merely listened to his inner voice and created an atmosphere of magic which he alone experienced but which he was able to convey in his paintings through the use of light and line.

To understand this inner emotion is to enter into what a critic would later call Rembrandt's "tragic expression", which as early as 1626 was already perceptible in the most famous paintings now in the Pushkin Museum in Moscow, such as *Christ Driving the Money-Changers from the Temple*. The clear, bright colour scheme of this biblical panel bears the hallmark of Pieter Lastman, yet despite a certain lack of harmony and unity, imperfect anatomy and doubtful perspective, the painting has an inner glow, a sort of premonition of the painter's genius and a strength of feeling which is greater than in his later works, when his technique had improved so extensively but his excitement and enthusiasm were no longer at their peak.

Human emotions and the passions of the soul occupied pride of place in seventeenth-century philosophy. These were transmuted to canvas by painters, and was spoken of in the salons of the day. When the young Rembrandt depicted the wrath of the young Christ and the shocked money-changers shaken out of their routine, he was exploring the matters which preoccupied his contemporaries. The artist's intention was not to distance himself from philosophical debate, he was posing the problem in pictorial terms which contained in themselves his intellectual emancipation and the stamp of his unique artistic approach.

Rembrandt's work showed none of the abstract and rather stilted "passions" of Lastman and his contemporaries. He patiently constructed his vision of the world and its inhabitants using a powerful natural and evocative touch. In later years, his spiritual nature and his artistic technique would produce an "aesthetic of emotion" without parallel.

He perfectly controlled light and space in his paintings. His credo was to work from life, and he adhered to this throughout his life. It was at this same period that the young painter began to make prints and produced a series of striking little portraits of himself.

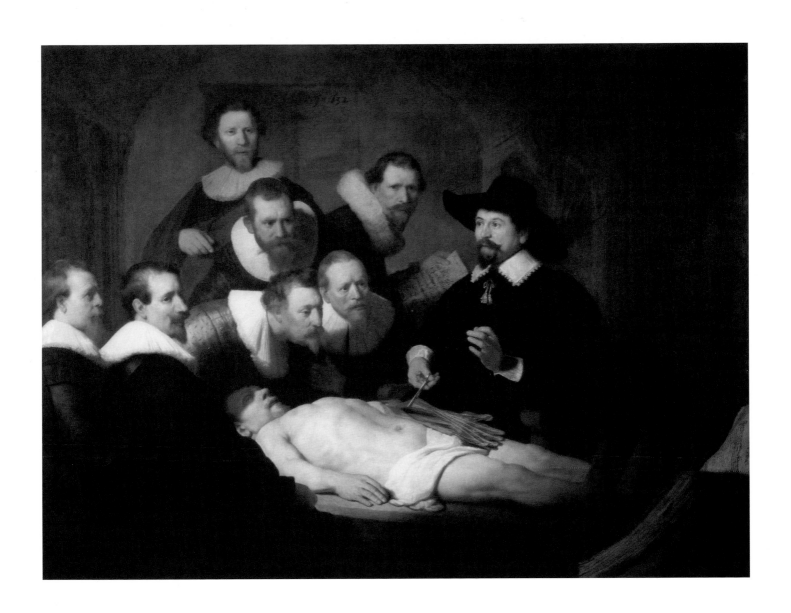

2. ***The Anatomy Lesson
 by Dr. Tulp***. 1632.
 Mauritshuis, The
 Hague, Netherlands.

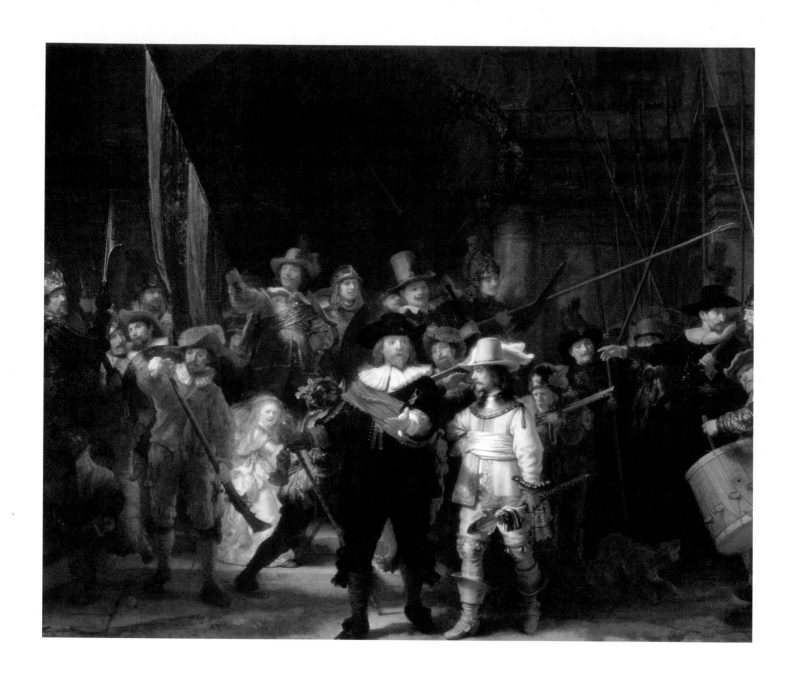

3. *The Night Watch*,
1642. Rijksmuseum,
Amsterdam.

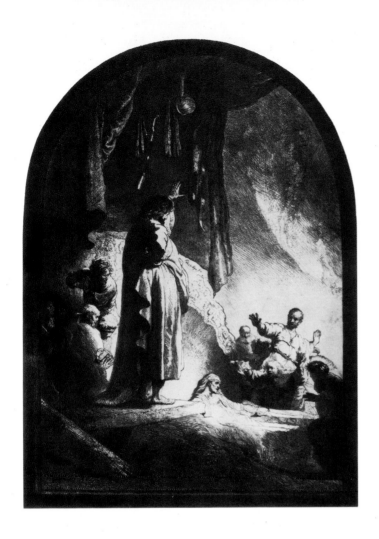

These faces, sometimes grimacing sometimes wearing a sardonic or iron expression, are always very expressive. They provide a foretaste of the portraits he would paint from the 1630s onwards. There are no self-portraits in the Russian museums, whose collections form the main subject of this book, but the portraits in the Hermitage in St. Petersburg and the Pushkin Museum in Moscow, entitled *Portrait of an Old Man* and painted in 1631, are examples of his earliest commissions which made his reputation as well as being the foundations of his wealth. As soon as his fortunes improved, he began to climb the social ladder as his parents had so fervently hoped.

He was only 22 years old when he took his first pupil into his studio. He had not yet mastered all the skills he needed from his teachers and his "imitations" of Lastman lacked assurance, but even if he was still "timid" in comparison with his later work, he never relented to convention.

4. *Lazarus' Resurrection*, 1630-1631. British Museum, London.

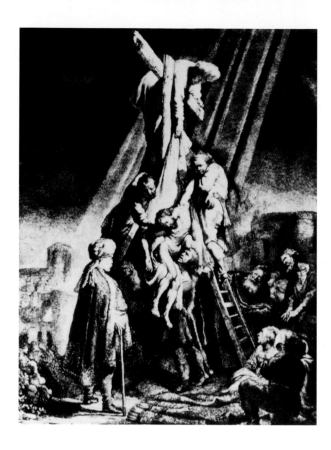

The infinite milling crowds of juxtaposed figures still eluded him, he was lost in a host of isolated subtleties; but he had already convinced several of his contemporaries that he was indeed skilled, and they were responsible for his gaining a reputation.

Constantyn Huygens, secretary to Prince Frederick Henry, a poet and traveller of refined tastes did not hesitate to compare him to Jan Lievens, who exhibited unparalleled precociousness in the quality of his youthful work. On 20 June, 1631, an Antwerp art dealer, Hendrijk van Uylengurgh, signed a contract with the young Rembrandt, offering to set him up in his house in Amsterdam.

The *Portrait of an Old Man* shows great originality in the choice of size and other inherent aspects of the picture. A painting's effect depends on its size and the distance which separates it from the viewer. In this work, Rembrandt lends space to his composition. The painterly devices he uses are diverse and his brushstrokes, sometimes discreet, sometimes more noticeable, translate the expressiveness of the model, by revealing his feelings as well as his features and social standing. Rembrandt's experience of the "passions of the soul" breathes life into what would merely have been a two-dimensional portrait had it been painted by another artist of his generation.

5. ***The Descent from the Cross***, 1633; Etching.

6. ***Self-Portrait***. 1669. Mauritshuis, The Hague.

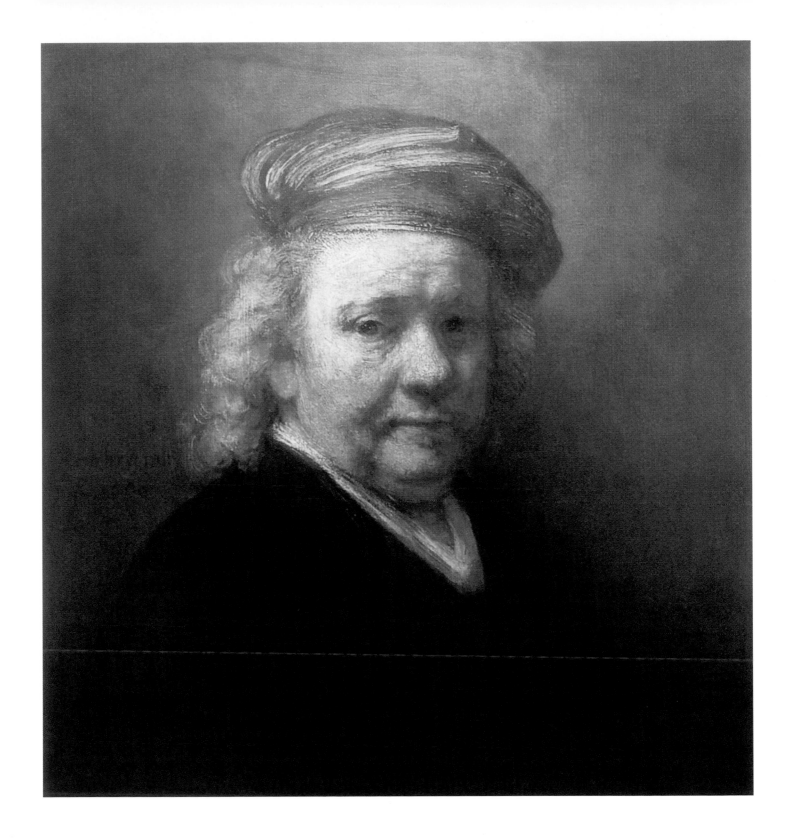

The *Anatomy Lesson by Dr Tulp*, painted in 1832, was commissioned by the Amsterdam Guild of Surgeons, as a result of the *Portrait*, whose owner had quickly spread his enthusiasm for the painter.

Rembrandt was young and proud and hardly ever left the studio. The *Self-Portrait in a Cap* in the Cassel Museum, painted in 1634, shows him very much in command of himself, strong and confident of his future. He knew how to vary his compositions depending on the model, yet at the same time he was constantly satisfying the demands of a permanent apprenticeship which enabled him to improve his technique and methods with each canvas he painted. This can be seen in *Young Man in a Lace Collar*, now in the Hermitage Museum in St. Petersburg.

This portrait, which was painted in 1634, meets the standards of the time, but already reveals a ghostly and unconventional understanding in the facial expression, in which the relaxed manner of the sitter emphasises his pleasant smile and the lightness of his features. The chiaroscuro gives the whole picture a sense of reality of tone which may well have flattered the young dandy who was concerned to look well turned-out, and one can feel the strength of the life spark which the artist captured for posterity.

It was during this decade that Rembrandt firmly established his reputation. While continuing to produce the same kind of portraits as his contemporaries, he constantly produced illustrations for contemporary writings and mythology through a succession of paintings in which his imagination was allowed a free rein. While at the height of his technical skills, the painter decided to place his models in a context. They were often submerged in scenery full of historical allusions, appearing in costume or surrounded by carefully-worked symbols. Despite this fancy dress, the men and women portrayed revealed their personalities without ever sacrificing the originality of the genre.

Rembrandt married Saskia van Uylenburgh on 10 July, 1634 and she posed for him in the first year of their marriage. During this era he also produced a few grisaille paintings as curiosities. The *Adoration of the Magi*, painted in 1632, is one of these less happy experiments, much practised by his contemporaries, but extremely rare in Rembrandt's work. He used one or two of these experimental works as originals from which to make etchings, but these were limited to a few test-pieces which he found sufficiently unsatisfactory to cause him to abandon this line of endeavour.

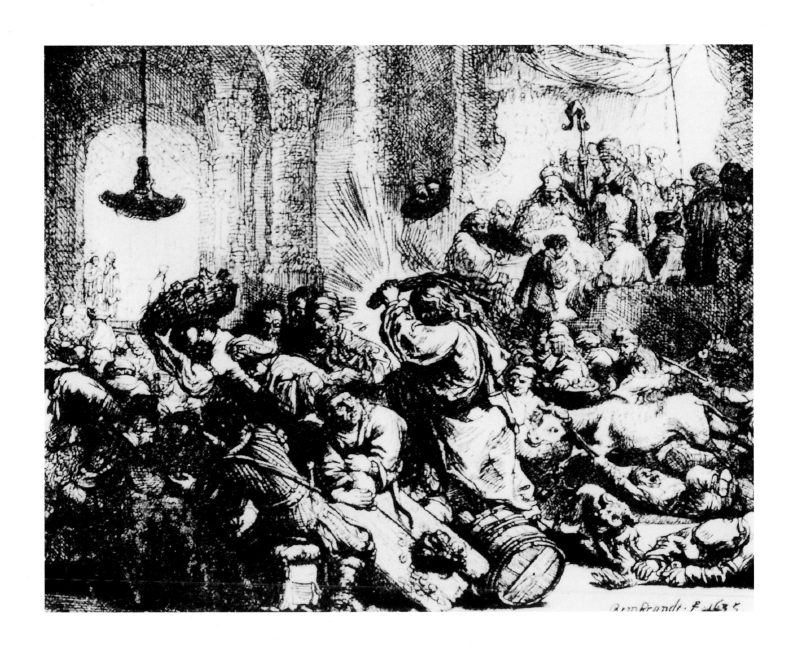

7. *Christ Driving the Money-Changers from the Temple*. 1635. Etching.

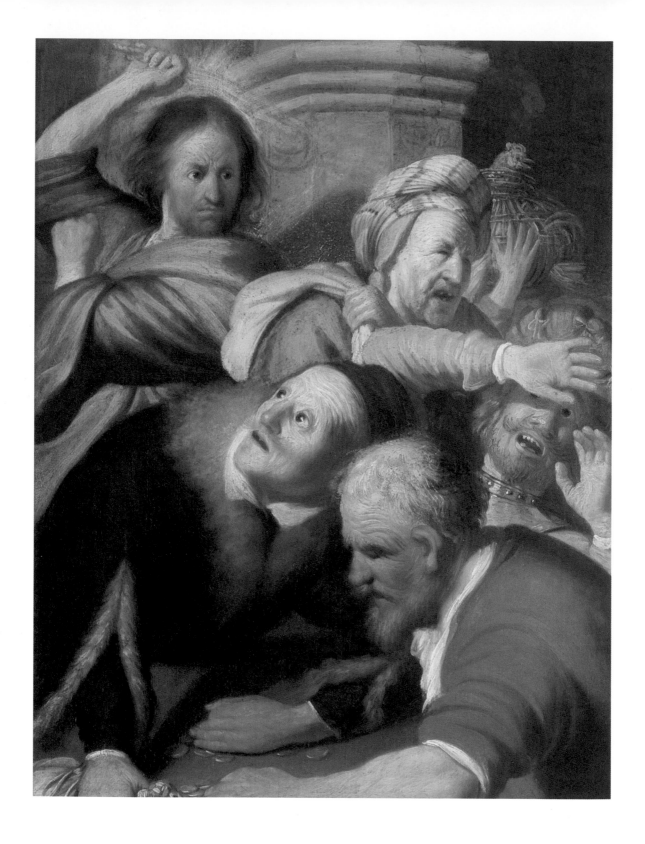

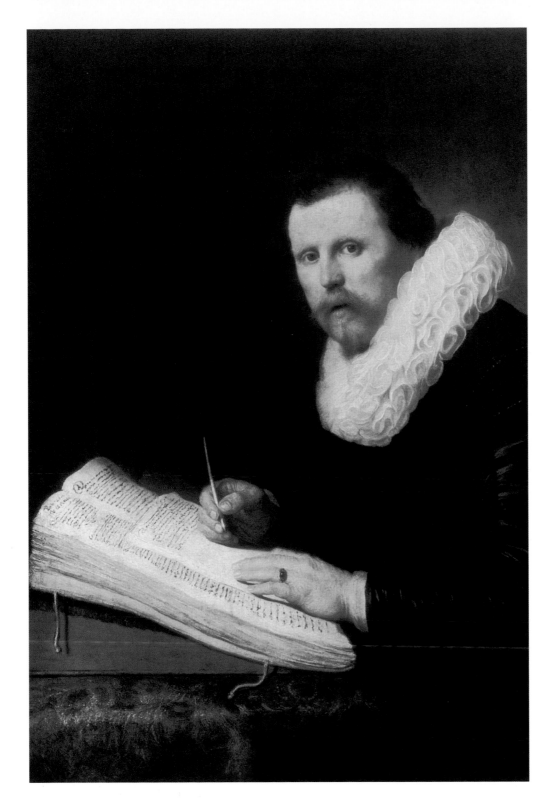

8. ***Christ Driving the Money-Changers from the Temple***. Oil on wood (oak), increased, 43 x 33 cm. Pushkin Museum of Fine Arts, Moscow.

9. ***Portrait of an Old Man***. Oil on canvas, restretched, 104,5 x 92 cm. St. Petersburg, Hermitage.

10. *The Adoration of the Magi*, drawing, 1632. Berlin-Dahlem.

There are few sketches by Rembrandt, apart from those which have now been revealed by taking x-rays of a few of his paintings. These do not enable us to establish the exact genesis of his paintings, but by comparing them with the grisailles he has left us, one can get a fair idea of the manner in which he painted. The only colours on his palette would be white, ochre and lamp black, and he would cover the canvas with large patches of transparent sepia which almost always remained intact where shade was called for in the painting; then the lit parts of the faces were modelled by a trace of white which would be worked in the shaded areas in long black or brown strokes. This is how the *Adoration of the Magi* was composed, though there were numerous retouchings, repaintings and constant modifications until the work was deemed to be completed. Through this analysis, it can be seen that ten years later, in *The Money-changers in the Temple*, the artist had lost nothing of his fiery temperament,

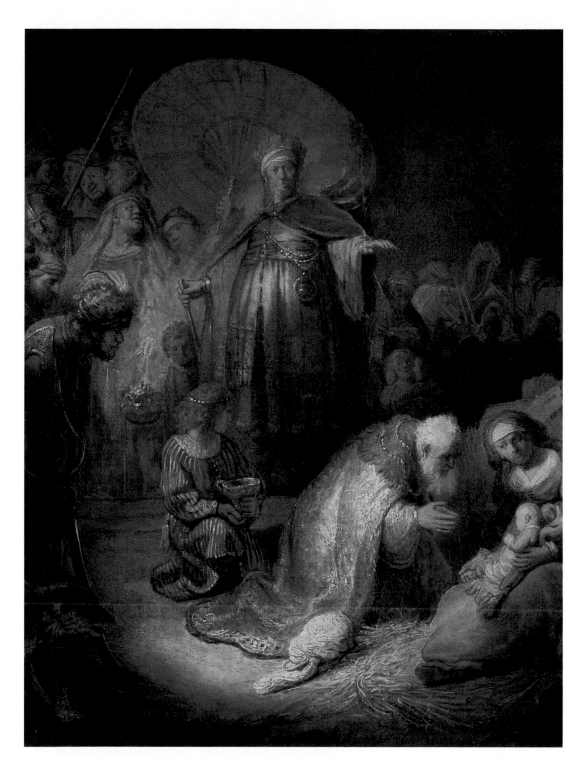

11. ***The Adoration of the
Magi***, oil on paper
glued to canvas,
restretched,
45 x 39 cm, grisaille.
Hermitage,
St. Petersburg.

12. *Saint John the
Baptist's Prediction*,
1637-1650.
Staatliche Museen,
Gemäldegalerie,
Berlin-Dahlem.

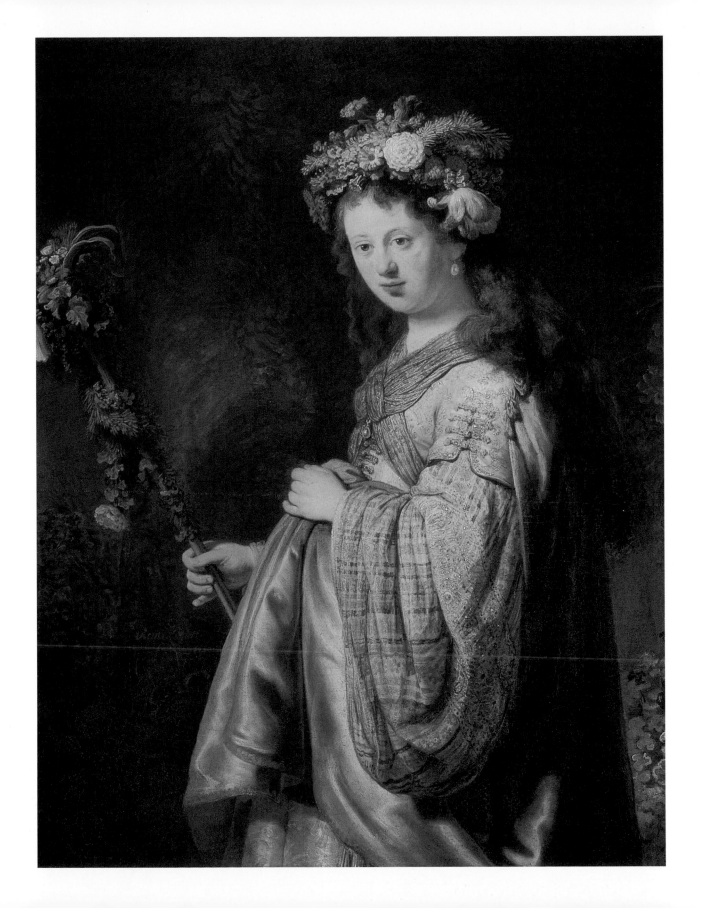

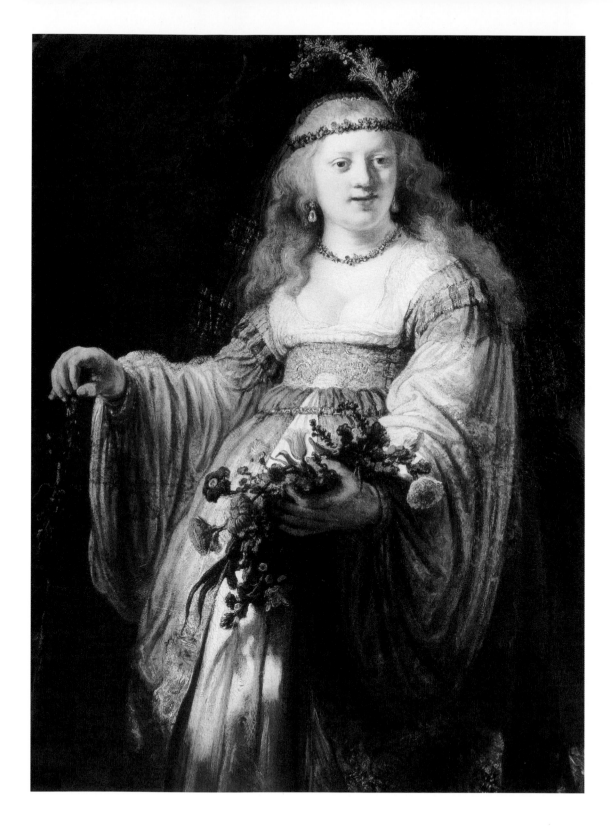

He is thus close to represent a very "oriental" world as the thread linking his "scenes". Yet this decade is characterised equally by a change in his method of painting, which is an analysis of his *Danaë*, of which the first version was painted in 1636, but which was completely reworked ten years later, makes it easier to understand. This painting clearly exposes the artist's interior world at a moment when it was fast evolving and reveals the "spirit" of his ambitions. Between the two dates, Rembrandt's art had undergone radical changes. *Danaë*, when studied in its two different versions, shows Rembrandt's desire, after his enthusiastic and prolific youth, to radically rework his painting, in the light of his later painterly vision. This is no slow evolution of his art, as was the case with *The Night Watch*, completed in 1642 after several years' work; this is a radical revision of a painting which had been completed many years previously, transforming it into a completely new work, produced using a different technique designed with a new sensitivity. *Danaë* thus summarises the two stages of his artistic life without the result being hybrid and denatured.

During the 1640s, Rembrandt painted many portrait. The diversity of his approach and the variety of brushstrokes gave them considerable importance. The simplicity and modesty of the portraiture caused great admiration and is indicative of the painter's talent and maturity.
The *Portrait of Baartjen Doomer* (1640) and the *Portrait of an Old Woman* (1650) – exhibited respectively at the Hermitage Museum in St. Petersburg and the Fine Arts Museum in Moscow – mark the beginning of the end of the artist's studies in this field. This was an unhappy period in the artist's private life.

In 1639, while his contemporaries were celebrating his genius, Rembrandt and his wife moved to the house he had just bought for thirteen thousand florins in the Jodenbreestraat, in Amsterdam. It was an elegant bourgeois dwelling on three floors, embellished with sculptures, and which inspired great pride in him until it precipitated him into financial difficulties.
His lifestyle was important to him, but he was also one of the most handsomely rewarded painters in Holland. He could easily command one hundred florins for a portrait, while the paintings of most of his contemporaries would be lucky to get between twelve and seventy-five florins. Fortune smiled on him until the death of his mother in 1640, and Saskia's demise two years later put an end to his joie de vivre. His son, Titus, born in 1641, would be his comfort and support until he died in 1668, six months before the birth of his daughter.

*19. **Saskia as Flora**. 1634, National Gallery, London.*

27

During this period, Holland became very wealthy as a result of its great maritime adventures, and was now becoming settled and complacent, confident in its future, and started to seek refuge in the conformity of its Golden Age and began to reject some of the great artists who had previously been highly acclaimed.

This was the fate of Franz Hals, who was now supplanted by painters with a greater aristocratic refinement, such as Gerard Dou, Ferdinand Bol and Govaert Flinck, all of whom had studied under Rembrandt.

The paintings in the Russian museums perfectly illustrate the tone which the artist gave his portraits during this decade. Baartjen Maertens Doomer, whom he portrayed in 1640, was not in high society, she was the wife of a craftsman who had close contacts in artistic circles; Rembrandt was immune to the conventions and he created this portrait with complete freedom, following his artistic impulses. He reproduces the lively expression of the lady whose cheerfulness emerges in every stroke. The whole depiction is based on the drawing which Rembrandt created as an integral part of the painting, following the expression to become more and more precise as the painting took shape. Painting his sitters as they really were, he imbued the portraits with their whole personality in order the better to bring them to life.

In seeking to bring out the "mobility" of the sitters, Rembrandt managed to obtain a likeness such as no one had ever been able to achieve hitherto. For more than ten years this method led to the apotheosis of Rembrandt's work.

The *Portrait of an Old Woman*, painted in 1650, was in the same vein. With complete mastery of his art, he gradually eradicated the dual perception of the world which had prevailed in his work hitherto, and which was typical of the previous decade, which consisted in distinguishing commissioned work from his personal vision of art, separating historical panels from the portraits. These works would now be combined in a single vision of the world which now bore a single signature – that of Rembrandt.

The large red cloth in *The Old Woman*, which was by no means typical of the time but which was favoured by the Master, as well as the old-fashioned "Burgundian" dress give the feeling that this was not so much a commissioned painting but rather a work of the artist's own inspiration. Yet the method used and the strict "objectivity" of the portrait are reminders that at the time Rembrandt had gained complete artistic freedom which would never be diminished.

"Man and his state of mind" would become one of his major interests, and the older he became, the more he reflected upon the internal solitude of those whose portraits he painted, in his eyes the only vector of a meticulous transcription of the personality,

20. **The Incredulity of St. Thomas**. Oil on wood (oak), 50 x 51 cm, 1634. Pushkin Museum of Fine Arts, Moscow.

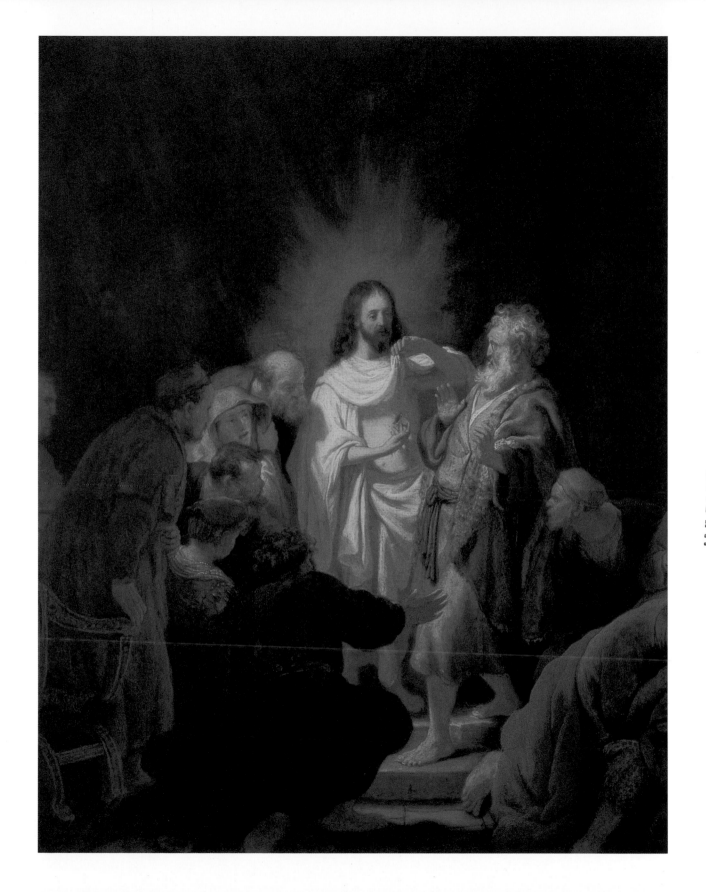

which through experience and observation he was able to turn into flesh and blood. By fixing a moment of life on the canvas without ever stopping it in its course, he was able to portray the richness hidden within his models and to make a look, an expression betray their most intimate thoughts and the secret of their existence.

Even those portraits which were his personal inspiration, for which Rembrandt often used the same models over and over, express the diverse nature of the "soul" and the profound nature of the human beings whom he placed within his genre scenes. That is how he "unmasked" his older brother, Adriaen van Rijn, whose features were used as a medium for characterisation in the various portraits of old men painted in the 1650s. These paintings are of great interest to those wishing to study the "Rembrandt method".

The two portraits of an Old Woman painted in 1654, in the Hermitage Museum in St. Petersburg and the Pushkin Museum in Moscow, used the same model and respond to the same criteria as regards their creation. The technique adopted, which is unique to the artist, is very varied as regards the manner of applying the colours around the eyes and in the shaded parts of the face. It is a series of brushstrokes and semi-transparent patches of colour whose outlines are blurred.

There are areas which are brightly lit, and a heavy layer of impasto consisting of short and long strokes of different colours. This method enables the artist to pass from light to dark, a technique he mastered better than anyone. Finally, over and above the intelligent amalgam of colours, the position occupied by these brushstrokes in space and the direction of the paintbrush on the canvas contribute to the three-dimensional effect so often admired in Rembrandt's work. There are numerous variations on these techniques among a number of Dutch artists, but theirs never matches the sureness with which Rembrandt used them.

In Rembrandt, the human face was always associated with the life which had shaped it. Furthermore, each portrait reflected a particular attitude in which the enigmas of existence could be read. The elderly people he painted in 1654 had a particularly tragic view of the world. They knew life to be full of pain, injustice and cruelty.
This world view was familiar to them, however, and did not cause them to rebel against it within themselves. Their loneliness was manifest, but it did not prevent the artist from discovering the complex ties which bound them to life, which he revealed in their wrinkled faces.

*21. **Emmaüs' Pilgrims**, 1648. Musée du Louvre, Paris.*

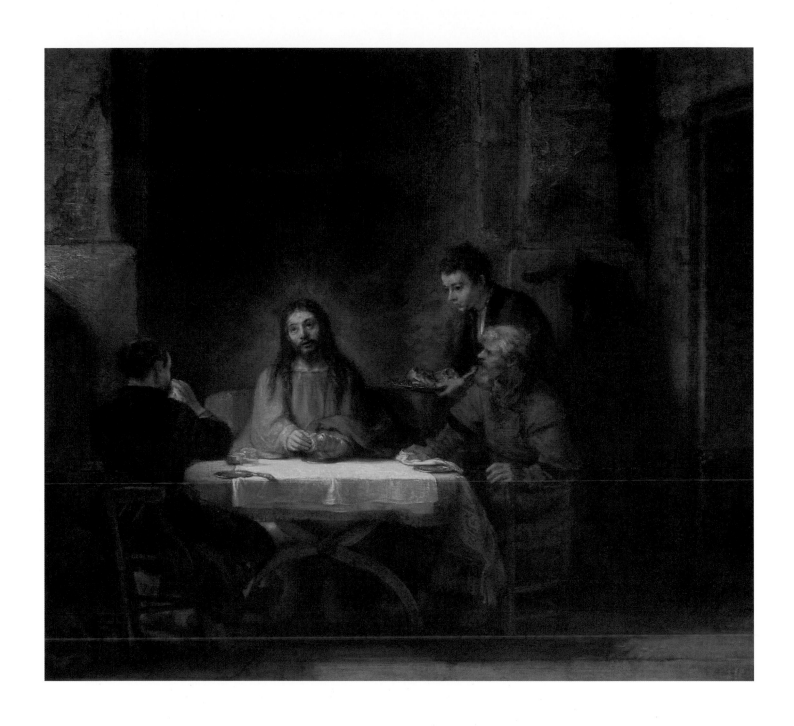

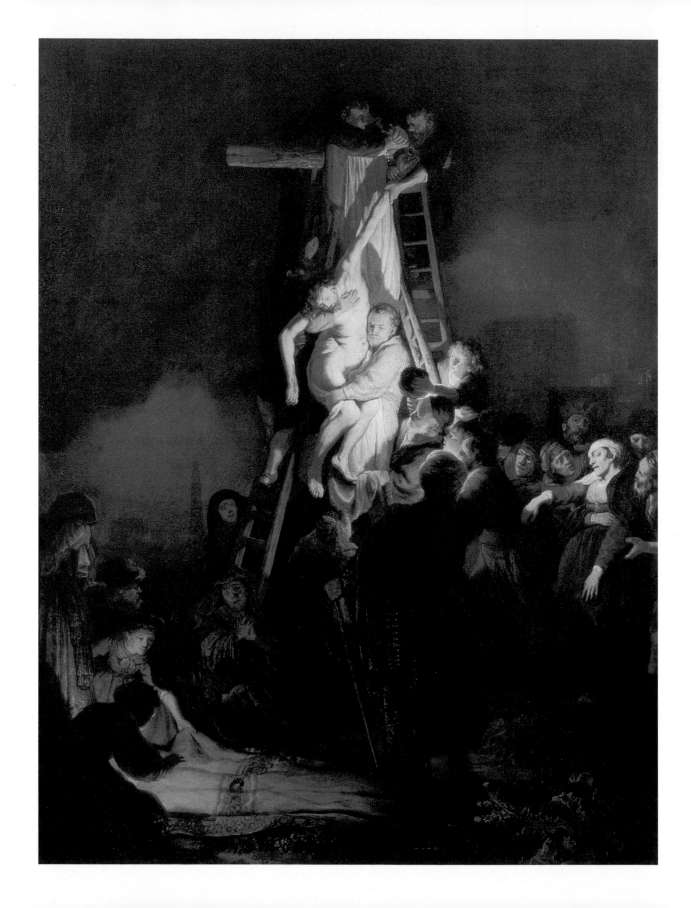

Rembrandt's old people are the incarnation of human wisdom. An exceptional spiritual value places these individuals above the daily routine and confers a tragic grandeur upon them and converts their philosophy into an absolute truth, one worthy of the whole nation. These portraits mark the apogee of seventeenth-century art in Europe, and have no direct descendants. It was not until two centuries later that artists would once again tackle the ambiguous relationship between man and his soul; but in the works of the romantic painters, the common people were not considered to have the wisdom or the grandeur of the figures painted by Rembrandt. His genius was to place them in a setting which would best express their personalities, so that in their individual expression they would lose any disadvantage conferred by their social status.

Rembrandt transferred his own feelings to his model. Having found in a human being what he shared with them in terms of their view of the world and their state of mind, he painted each of the numerous portraits which made him famous like a fresco reflecting the image of his century. Less than a genre, Rembrandt's portrait is scrap of truth torn from mankind.

Despite the importance of landscape painting and genre scenes, the Dutch painters continued to draw their inspiration for subject-matter from portraiture. Since such portraits were a source of both honour and profit, many artists were unable to resist flattering the images commissioned by their patrons and this has not always contributed to the posthumous reputation of the artists. Seeking to please rather than to "bring out the expression", many of Rembrandt's pupils abandoned the style which best suited them, large brushstrokes and thick paint for a lighter touch, one which was smooth and too frequently inconsequential. This was a style which many used, born of financial success the growth of the middle classes and changes in fashion.

Even though the most competent painters translated this shift of opinion, which was already being served by such masters as van Dyck, Rembrandt did not become one of them and continued to defy the artistic currents and his accumulating financial woes working without making the slightest concession to fashion. In the late 1640s, when Hendrickje Stoffels, became his model and went to live with him in the house on Jodenbreestraat, he continued to pursue his own aesthetic style, alternating commissioned portraits with those of his own inspiration, and with historical scenes in which he adroitly combined his models with his own "visions" of the world.

22. *The Descent from the Cross*, 1634.
Oil on canvas, restretched,
158 x 117 cm.

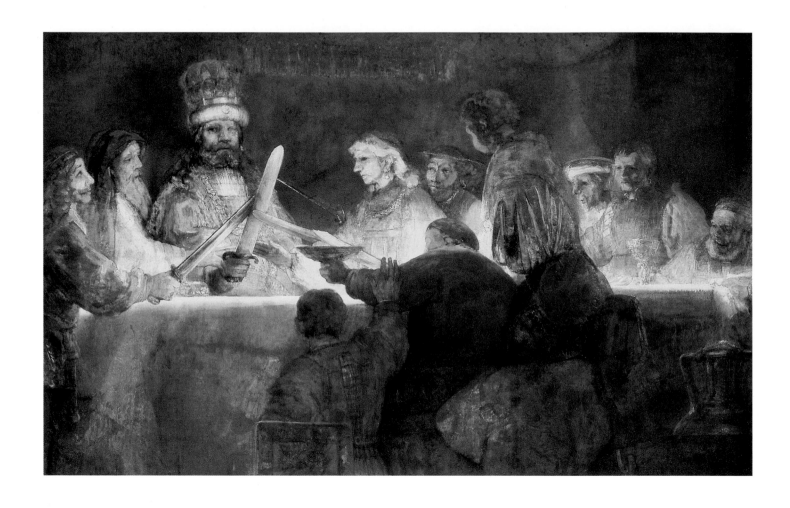

23. ***The Conspiracy of
the Batavians***, 1662.
Nationalmuseum,
Stockholm.

24. ***The Descent from
the Cross***.
1633-1634.
Alte Pinakothek,
München.

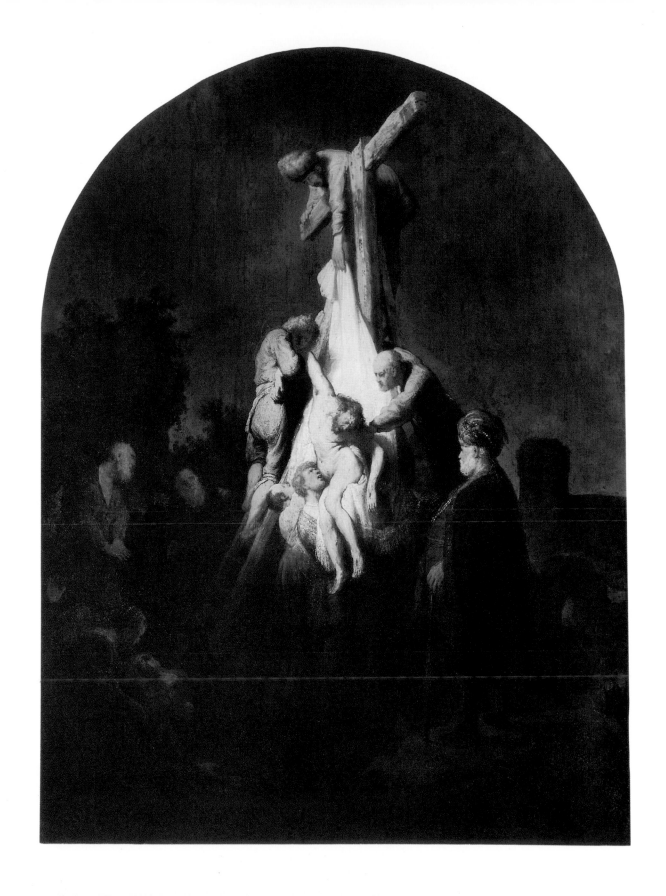

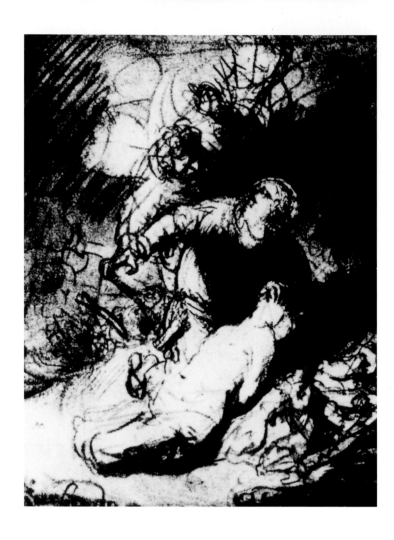

25. *Abraham's Sacrifice*.
Around 1636,
drawing. British
Museum, London.

26. *Abraham's Sacrifice*.
Oil on canvas, 1635,
restretched,
193 x 132,5 cm,
St. Petersburg,
Hermitage.

His artistic language had attained an unequalled virtuosity. Sometimes resorting to very simple methods, sometimes using an ingenious and complex mixture of brushstrokes (thick, semi-transparent or transparent), he managed to create "unities of the soul" in which each element is inseparable from the whole. There is no splash of colour, no brushstroke which is not important in itself, all the elements of the artistic language have acquired a psychological and spiritual basis which only exists to the extent that they are imbued with it. That is why it is practically impossible to extract and isolate the image from its psychology and to find adequate terminology with which to define it. It is an element which is inherent in painting.

In the second half of the 17th century, Holland was to experience a series of upheavals, such as the war against England in 1652. This was the start of a difficult period.

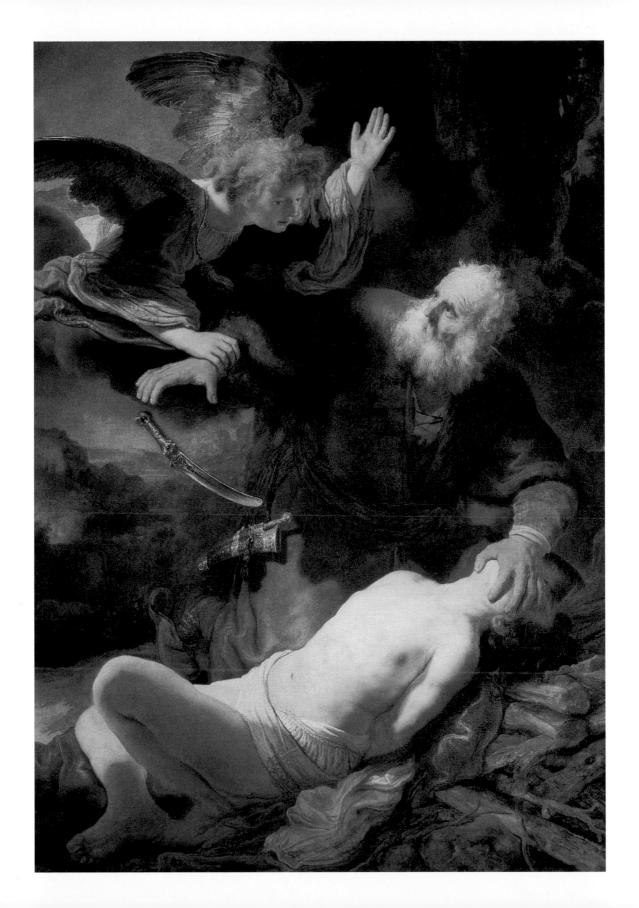

At this time, while the Dutch were fearful of their future, Rembrandt, like a magician who remains untouched by current events, continued to present the public with images of a different reality. Deaf to the agitation of the Dutch populace, he lived in a world which he had redrawn to his own specifications, consisting of reds, browns and blacks, whites and yellows mixed in subtle touches, melting together on the canvas beneath his magical brushes.

He seemed to care only about his combinations of colour and light with which he played so skillfully in the midst of the shadows. Rembrandt was so captivated by his art, it became almost an obsession, and he could only perceive the world through his paintings. Pursuing his dream, brushes in hand, he continued to create portraits in oils and to make etchings of others, yet without abandoning the scenes from the Bible in which people and the world were reflected.

Life continued around him but he appeared to remain unaware of it. He embarked upon a tumultuous course which led him into the greatest financial difficulties. The artist had been showered with honours and the love of Hendrickje, the patient force behind his illuminations, had hidden the serious consequences and had detached him from the conventional and pompous society with which he refused to compromise.

In July, 1656, heavily in debt, Rembrandt found himself unable to meet his commitments. His income no longer covered his expenditure and he was forced to leave his lovely home in Amsterdam, abandoning it to the bailiffs. His magnificent art collection, which included many contemporary works, as well as those by Raphael, Giorgione and van Eyck, antique statues and Chinese and Japanese works of art, suits of armour, minerals and even a lion skin, was auctioned off. Yet he was not driven into bankruptcy.

Hendrickje and her son Titus turned themselves into a firm of art dealers and made the Master into their employee, so that the income from the sale of his pictures would not be swallowed up in reimbursements to his creditors.
Rembrandt's new home in the working-class Rosengracht district, was by no means unpleasant. He continued to work ceaselessly despite adversity, drawing inspiration from the working people though still retaining the friendship, and even the admiration, of the great and the good. In 1667, Cosimo de Medici, the future Grand Duke of Tuscany, visited him in his studio in order to purchase one of the two *Self-portraits* which are now in the Uffizi Gallery, in Florence.

*27. **The Parable of the Labourers in the Vineyard**, 1637,* oil on wood (oak), reinforced, 31 x 41 cm. St. Petersburg, Hermitage.

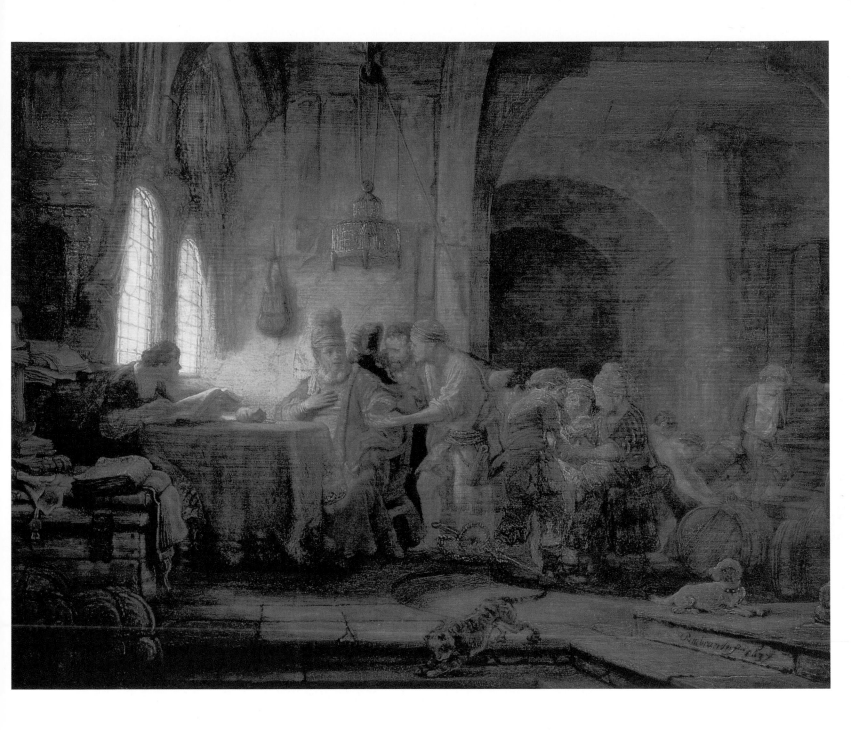

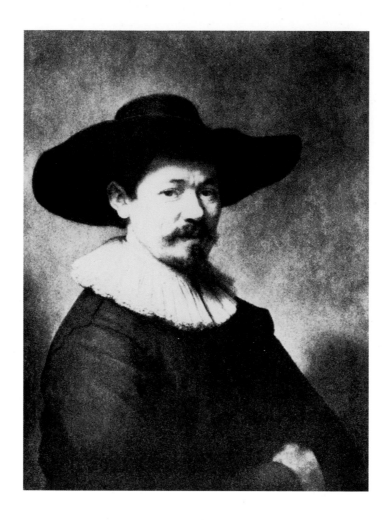

28. ***Herman Doomer***, 1640, Metropolitan Museum of Art, New York.

29. ***Portrait of Baartjen Maertens Doomer***, *wife of Herman.* Oil on wood (oak), increased, 76 x 56 cm, St. Petersburg, Hermitage.

While measuring the inanity of human pretentions, Rembrandt was able to escape the self-pity of deep depression because even in this time of crisis, he still had his painting left. His work lost more constraints and became more ethereal.

The 1650s produced more master-pieces in the painter's catalogue, some of which are in the Russian museums. The *Young Woman Trying on Earrings* dates from 1657. It is a painting of a rather rare type in which a young beauty admires herself in a mirror. Although this is an allegorical image of vanity which was very much of the period, it cannot rival *The Return of the Prodigal Son*, generally considered to be the perfect illustration of Rembrandt's mature genius. The latter painting gives a good idea of the artist's own philosophy of life, and his attitude towards existence, which he regarded as artificial and superfluous.

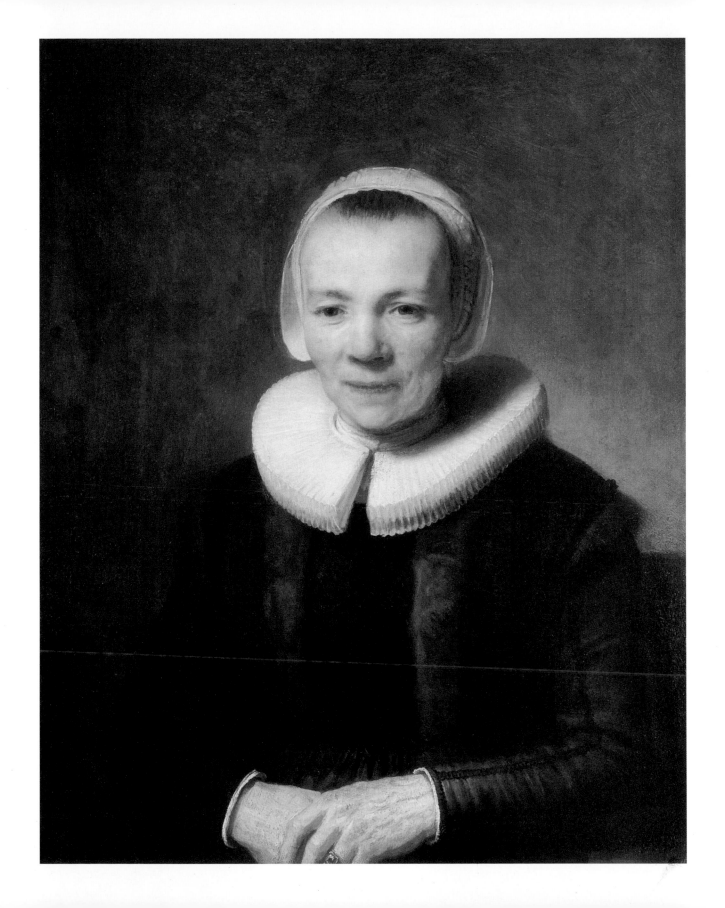

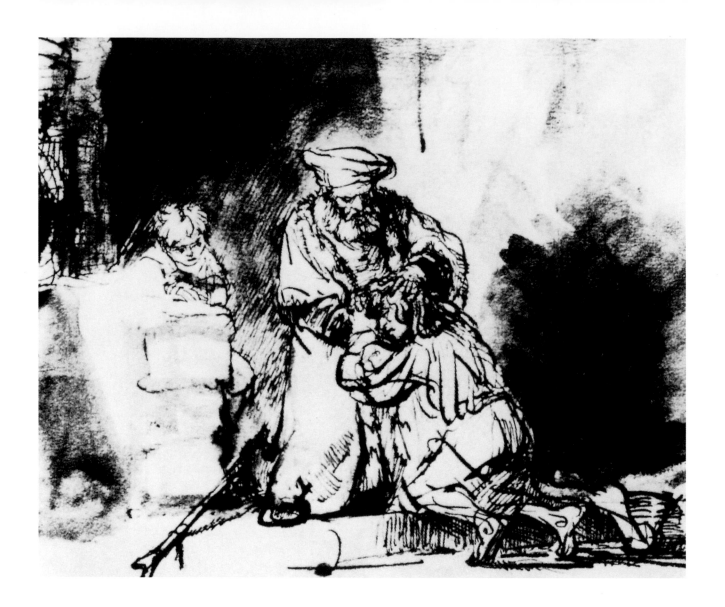

30. **Return of the
 Prodigal Son**,
 drawing. Teyler
 Museum, Haarlem.

31. **David and Jonathan**,
 1642. Oil on wood
 (oak), increased,
 73 x 61,5 cm,
 St. Petersburg,
 Hermitage.

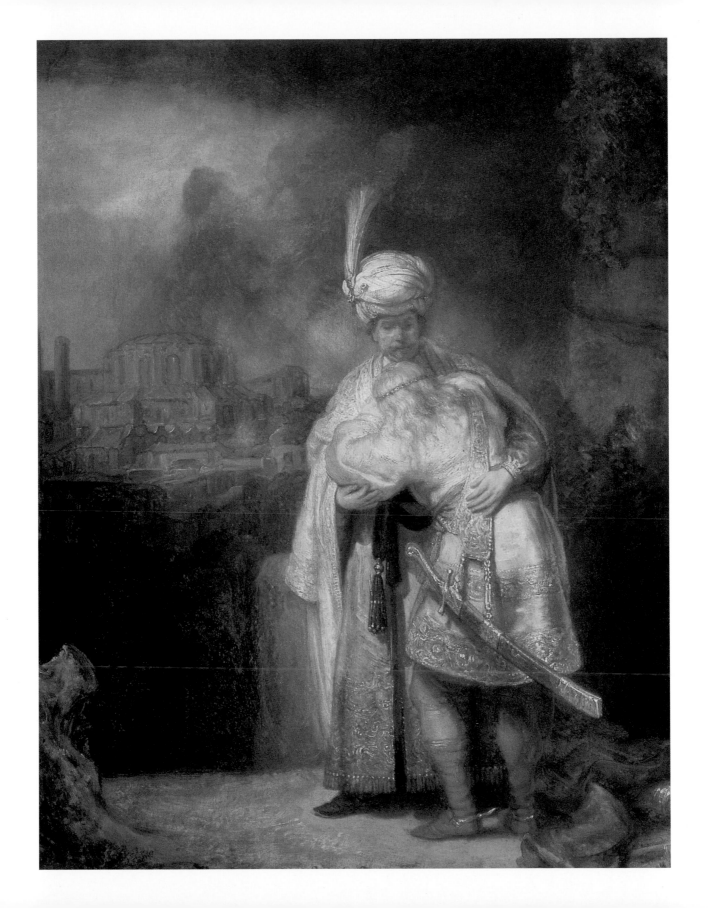

The historical paintings of the last decade of his life clearly illustrate the essence of Rembrandt's art, the subjects which interested him the most and what he was able to offer in terms of aesthetics.

Haman, Esther and Ahasuerus, painted in 1660, is indisputably one of the most peaceful paintings of the Master, as well as one of the most taciturn. Esther has just made her accusation to the king who sinks into a profound meditation, refusing to believe the truth revealed to him. The lack of any outside action and the apparent isolation of the figures from each other enables the artist to reveal the character of each of them, the relationship between them and the fate that awaits them.

Man face-to-face with himself: this was Rembrandt's major preoccupation when he painted a portrait. It was these same problems, seen from another era, transposed to the biblical world, which would continue to preoccupy him until he breathed his last.

Each of the figures in *David and Uriah* (1665) painted in the foreground against a dark background, seems to be searching his own soul; although there is no explicit indication which would interpret the scene exactly, the relationship between the protagonists clearly illustrates the painter's intentions. An oriental dignitary accepts his loss and accepts his fate with self-denial and a monarch who has just ordered his arrest and execution, yet whose face expresses sadness rather than his wrath. An old man and several prophets are witnesses to the scene.

Yet it is in the *Return of the Prodigal Son* painted in 1668-1669, that Rembrandt attained the perfection of his art. It was a historical quest which had reached its conclusion, the Gospel parable made flesh and for the artist perhaps, who was over sixty when he painted it, though in a perpetual quest for the truth, a response to the preplexing question of the supreme meaning of life. The reuniting of father and son were a possible summing up of their earthly existence and all the sufferings experienced during their long separation. Man is shaped by his own past. The moment of the actual meeting is so emotional that legitimate joy has given way to something resembling sadness, but which is probably more like a serene melancholy, regret for the lost years.

Although very different as to the dates when they were painted, the scale of the figures, the size of the canvas, the composition and even the technique give these three works perfect spiritual unity through the emotions they portray. It has been said that the heroes in Rembrandt's later works exist "outside time and space".

This is only true if one considers that they exist outside a space filled with everyday objects and that they live outside time filled with everyday routine.

32. **Old Woman with Glasses**, 1643. Oil on wood, increased, 61 x 49 cm, St. Petersburg, Hermitage.

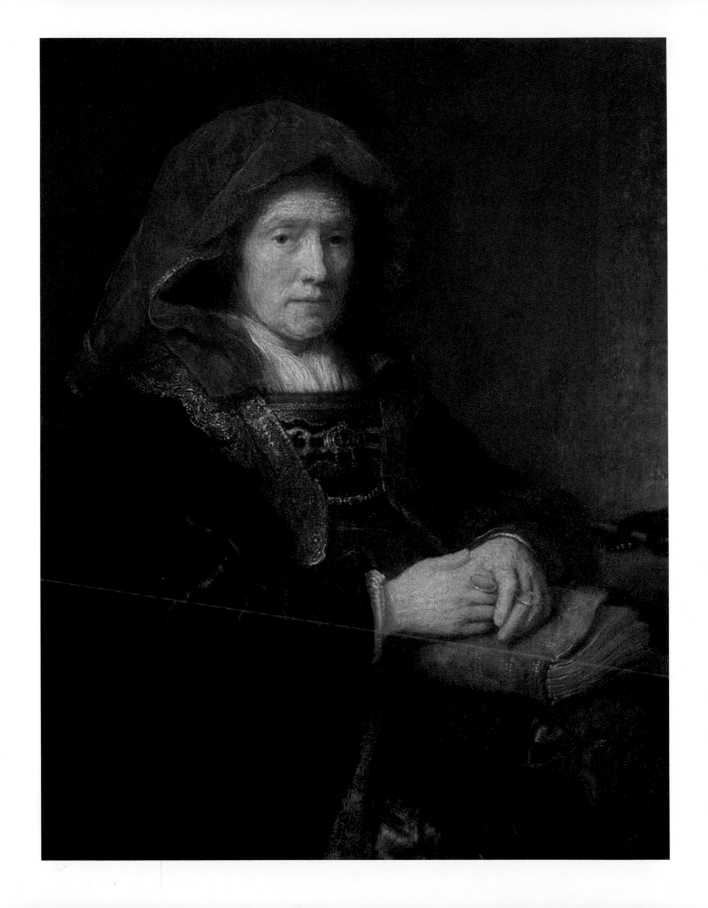

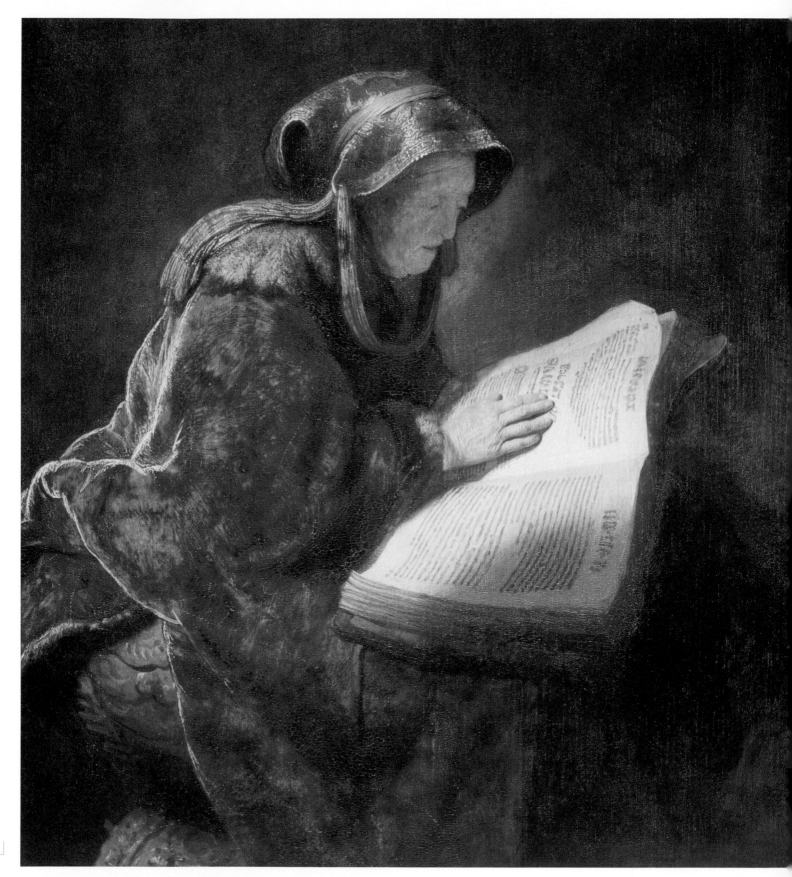

33. **Anna the Prophet, or Rembrandt's Mother**, 1631, Rijksmuseum, Amsterdam.

34. **Drawing from the Portrait of Balthasar Castiglione** by Raphael, Albertina, Vienna.

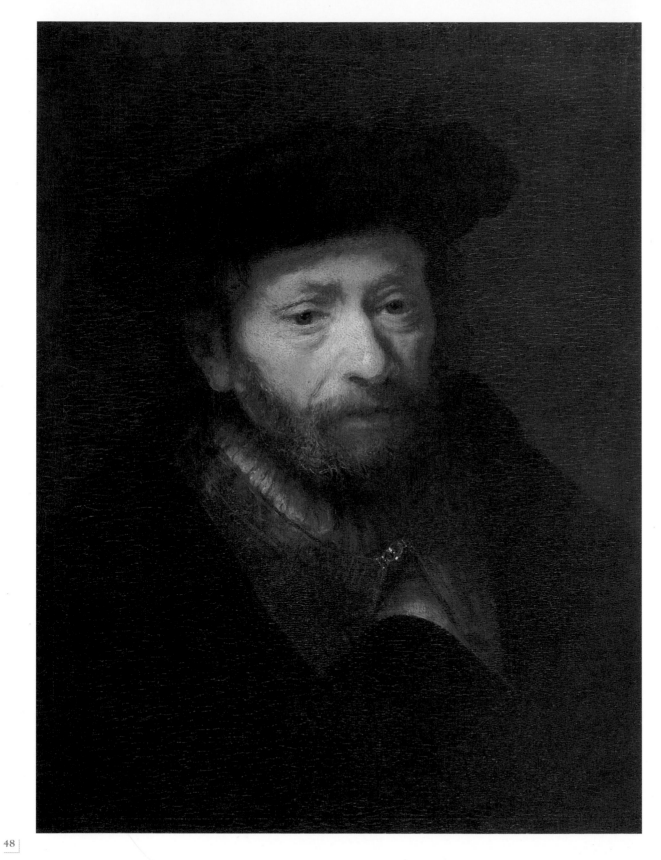

Their lives are governed by a clock which does not apply here on earth, it is a different rhythm of time and space. There had been a period when the artist had delighted in creating an imaginary and flamboyant Orient. Henceforward this type of background seemed to him to be superfluous and he contented himself with dressing his figures in a few exotic fripperies. All other indications of place and time are absent or merely hinted at. The Roman portico in the *Prodigal Son* is barely discernible, the table, the ewer, the dish of apples and the cup in Human's hand are the only indications of the feast held by Esther and Ahasuerus. In the *Return of the Prodigal Son*, the artist went as far as leaving out the characters mentioned in the Bible and who had been part of the pictorial tradition of the parable.

35. ***Portrait of an Old Man***, oil on wood (oak), 51 x 42 cm, St. Petersburg, Hermitage.

36. ***Child in a Cradle***. Circa 1645. Drawing. Unknown location.

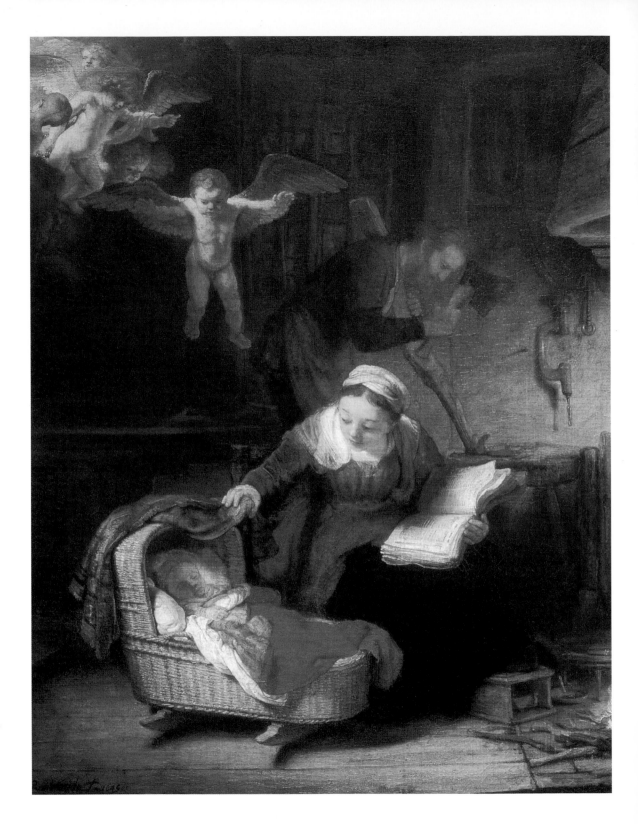

37. **The Holy Family**,
1645. Oil on canvas,
restretched,
117 x 91 cm,
St. Petersburg,
Hermitage.

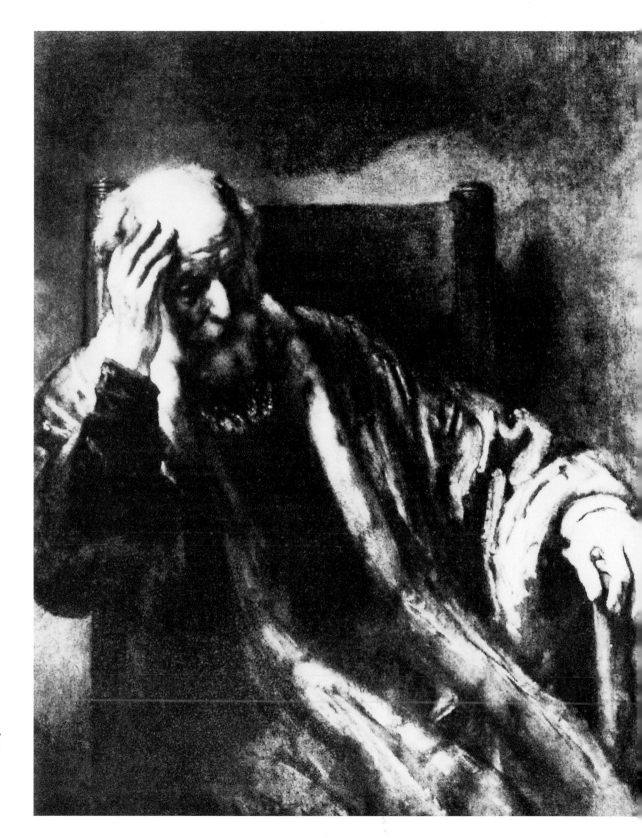

40. **Old Man in an Armchair**, 1652. National Gallery, London.

41. **Portrait of an Old Lady**. Oil on canvas, 82 x 72 cm, Pushkin Museum of Fine Arts, Moscow.

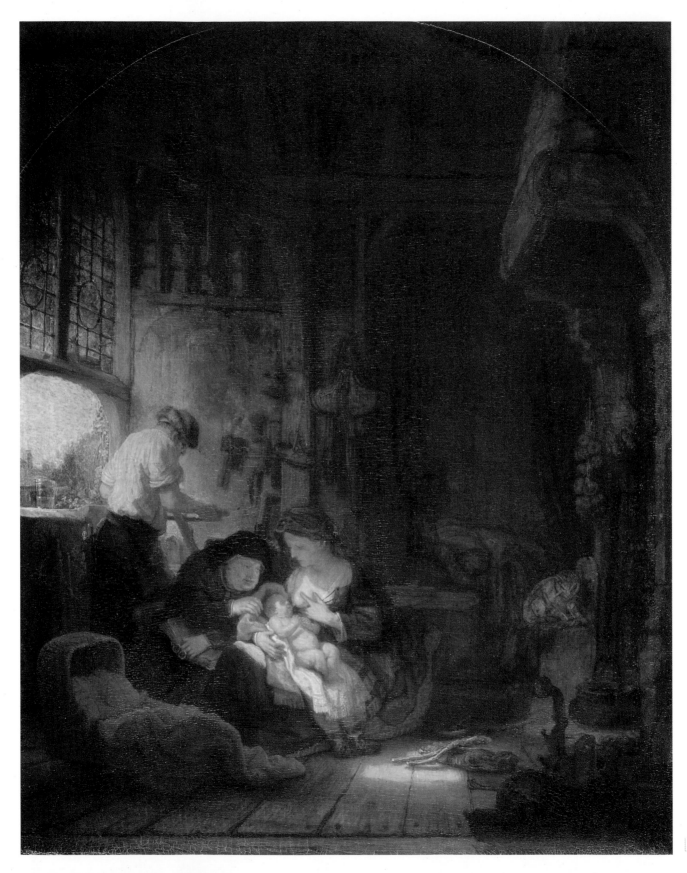

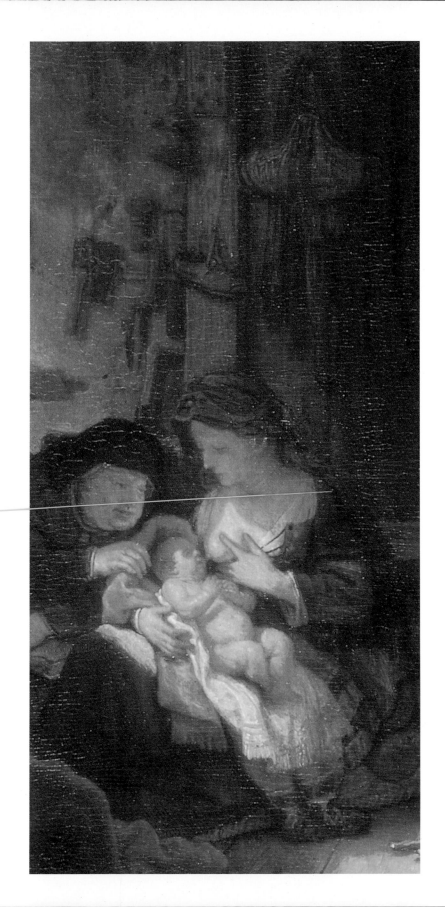

39. ***The Holy family***,
1640, Musée du
Louvre, Paris.

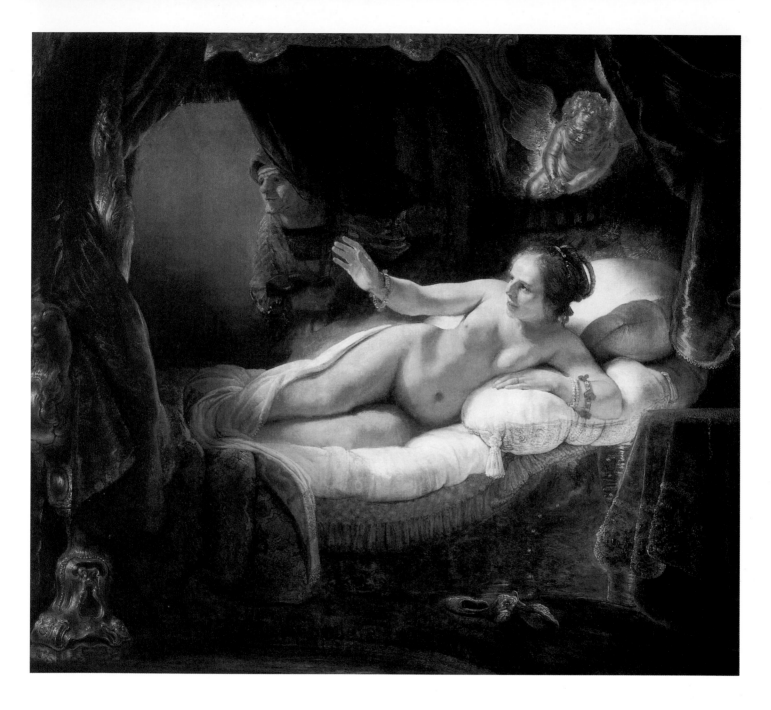

38. ***Danae***. Oil on canvas, covered with glue, 185 x 203 cm, St. Petersburg, Hermitage.

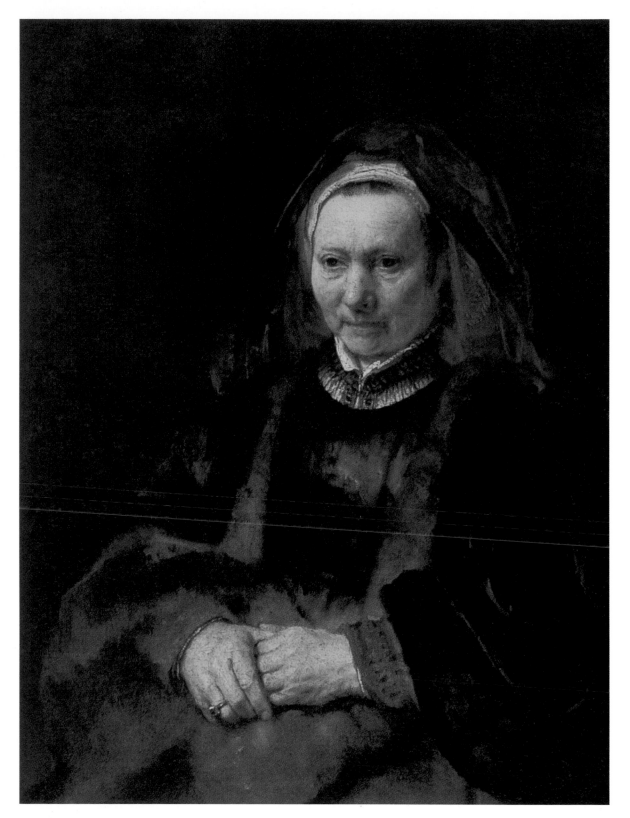

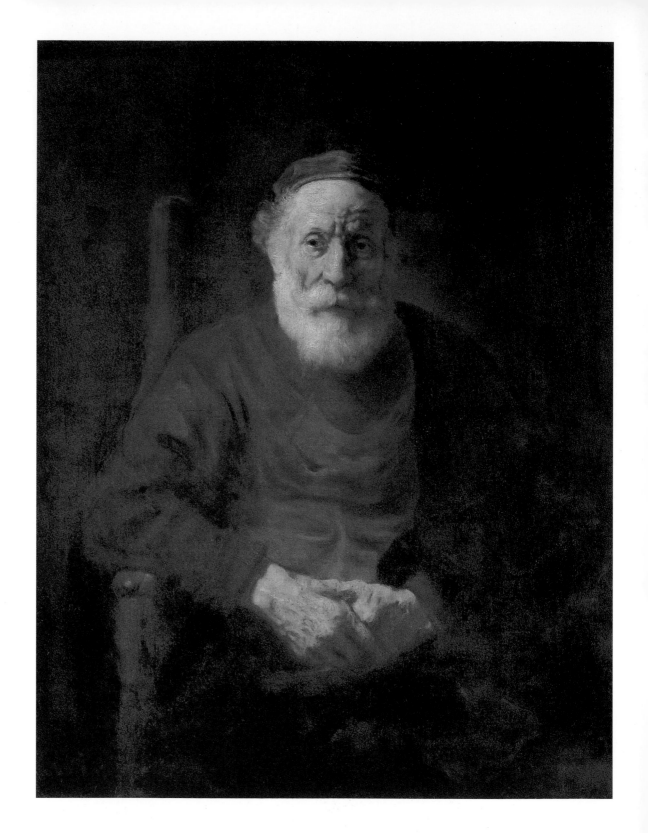

42. ***Portrait of an Old Man in Red***.
Oil on canvas,
restretched,
108 x 86 cm,
Hermitage,
St. Petersburg.

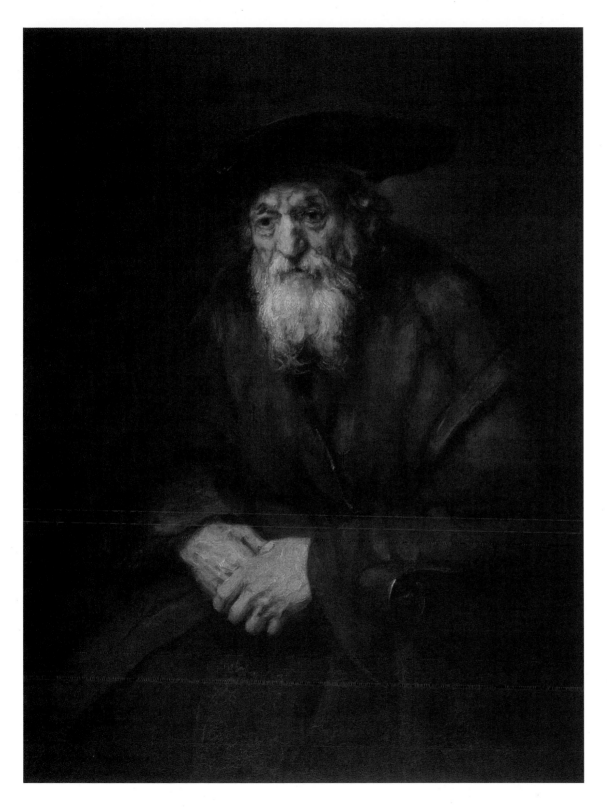

43. ***Portrait of an Old Jew***.
1654, oil on canvas,
restretched,
109 x 84,8 cm,
originally 89 x 76,5 cm,
Hermitage Museum,
St. Petersburg.

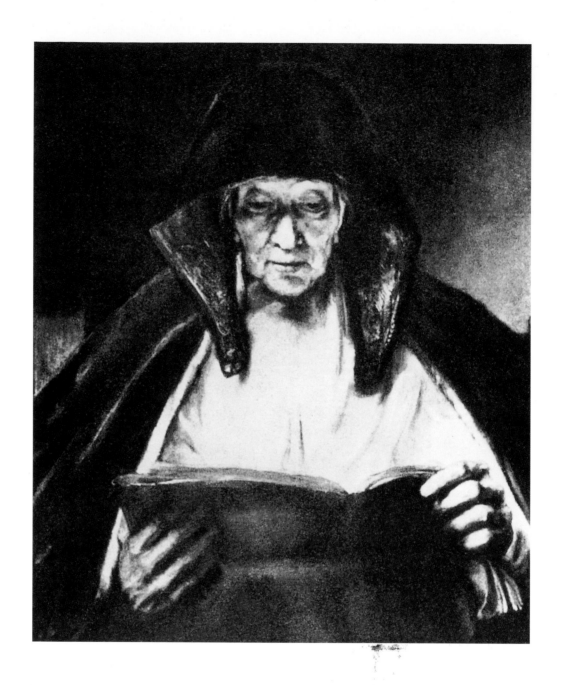

*44. **Old Lady Reading**.*
1655, Duke of
Buccleuch's collec-
tion, Scotland.

*45. **Portrait of an Old
Lady**. 1654.*
Oil on canvas,
109 x 84,5 cm.

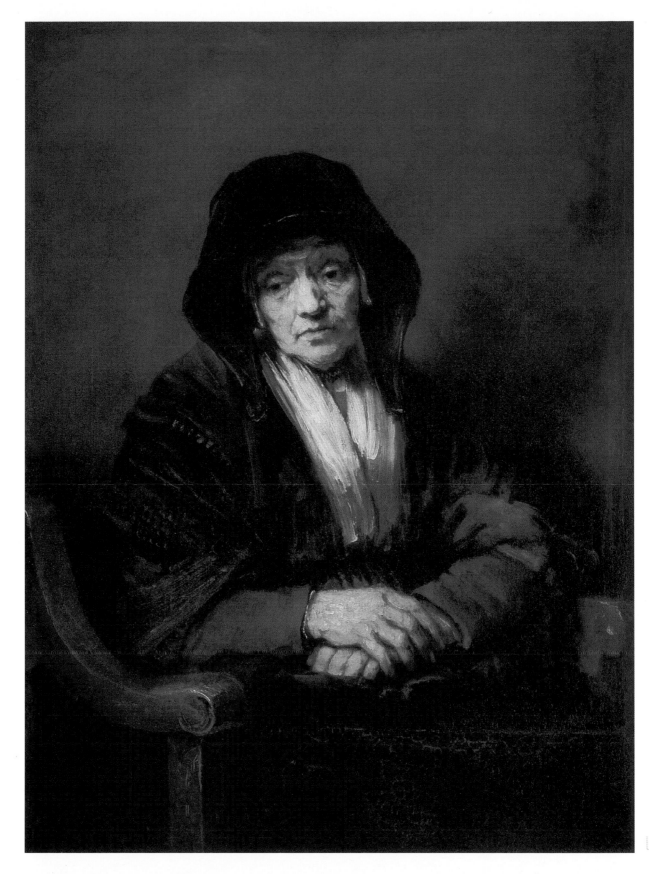

In Rembrandt's works created in the 1630s, the importance of the action was determined by the magnificent backgrounds. Those of the 1640s were characterised by their depictions of everyday scenes.

Henceforward, as his final works show, everything concentrated on the inner worlds of the figures whose intensity throws back into the shade anything that appears to be subordinate. The painter now concentrates completely on the soul of his models and has deep compassion for them. They are looking inwards at themselves, and all the attention is focused upon them. Everything that is secondary and fortuitous is eliminated in order to show what is in their minds.

Rembrandt's figures are now either immersed in the limelight or almost invisibly submerged in shadows, depending on the painter's whim. Yet wherever they are placed in the painting, they remain isolated from the world and from other human beings, as if strangers to the course of life. One sometimes has the impression that they cannot see, despite the ties which bind them to their common fate.

Rembrandt's figures passively accept the grand designs which are their inexorable fate but they are also confronted with their own lives. Even Esther, who by her actions directed the course of events in order to deliver her people from a hideous fate, is eventually merely an instrument of God's will and that of Mordecai. The beautiful gentle queen performs what is written for all eternity with a dignity that is full of modesty. In Rembrandt's later work, human life is attached to the concept of destiny which while being inherent in man, escapes him completely. His destiny can be followed with dignity, the figures seem to say to the Old Master, one may rebel internally but it is not possible to fight it.

Rembrandt's sombre genius understood the sad, almost unconscious undertone of this impassioned impetus. There is an echo here of everything that would be most surprising in the work of Byron. "Before me there is the head of a man who with one clean line can only be half-seen", wrote the young poet Lermontov two hundred years later when viewing a Rembrandt's portrait. "All around, there are only shadows. His haughty expression is both burning and yet at the same time full of anguish and doubt. Perhaps you have painted it from nature, and that this effigy is far from being ideal! Perhaps you have depicted yourself as you were during your years of suffering? Yet a cold look could never penetrate this great mystery and this extraordinary work will remain a bitter reproach to heartless people".

46. *Portrait of an Old Woman*. 1654, oil on canvas, restretched, 74 x 63 cm, Pushkin Museum of Fine Arts, Moscow.

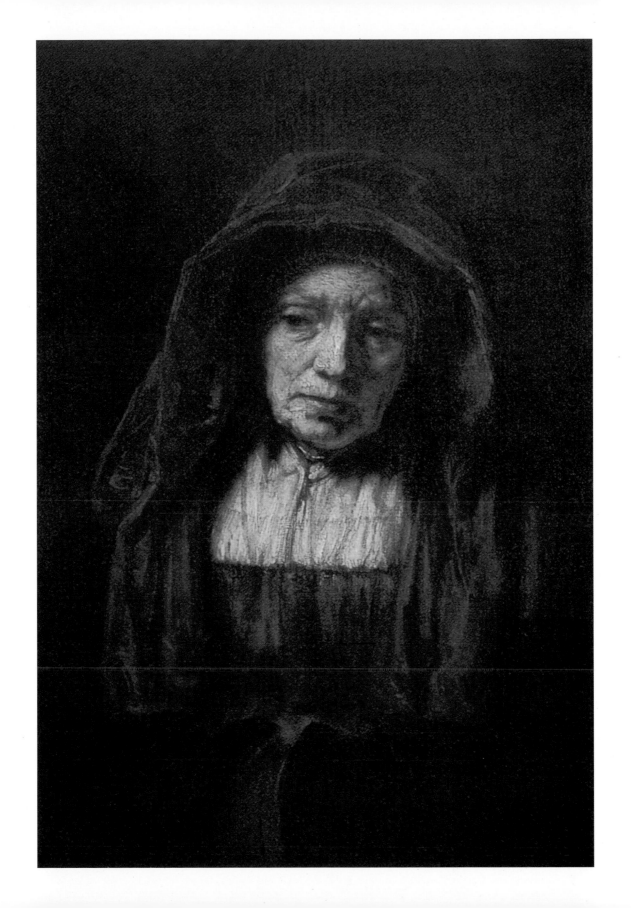

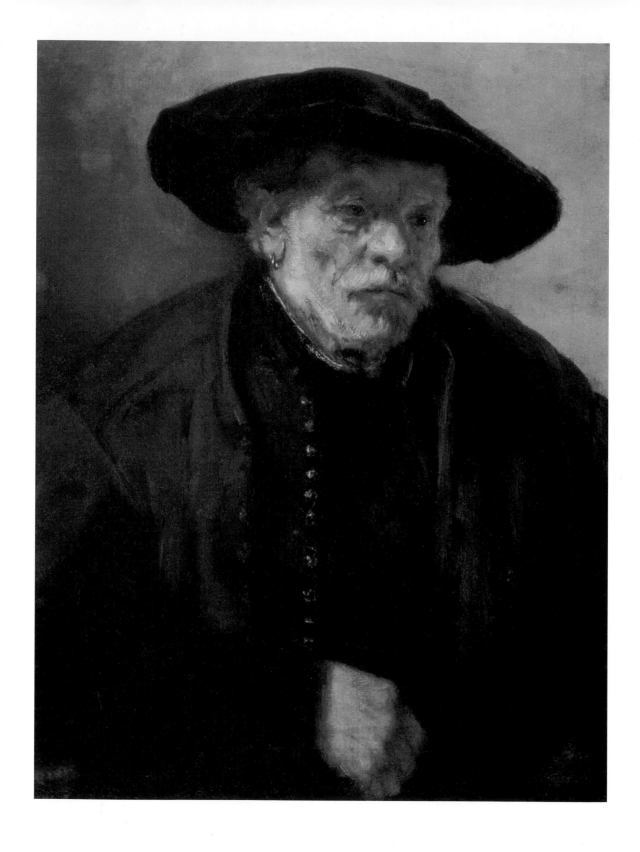

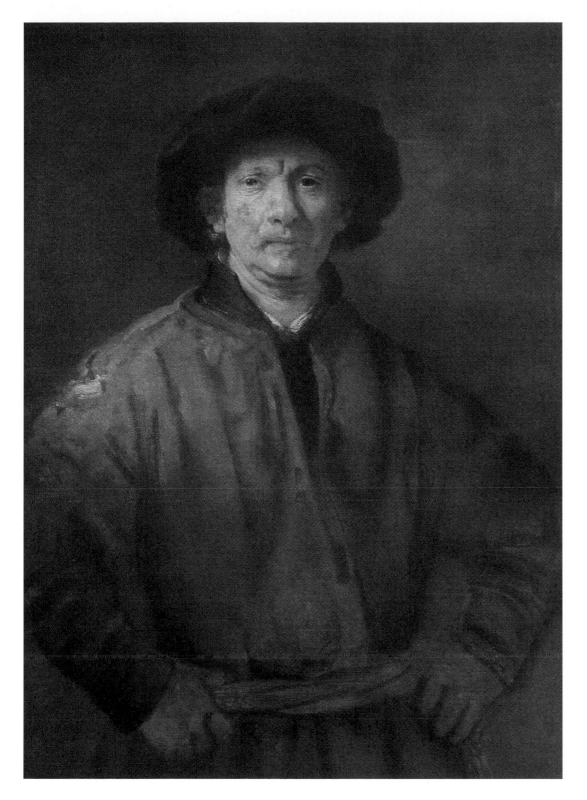

47. ***Portrait of Adriaen
van Rijn***, 1654.
Oil on canvas,
restretched,
74 x 63 cm. Pushkin
Museum of Fine Arts,
Moscow.

48. ***Self-Portrait***, 1652.
Kunsthistoriches
Museum, Vienna.

49. **Saskia** (?) **in front of a Mirror**. 1630s. Drawing. Musée Royal des Beaux-Arts, Brussels.

50. **Young Lady Trying On Earrings**. Oil on wood, increased, 39,5 x 32,5 cm, Hermitage, St. Petersburg.

The character of Rembrandt's figures are deaf to this vision of man which the Romantic period would celebrate with such misguided enthusiasm. It is probably *Titus van Rijn in a Monk's Habit* which Lermontov, then only 16 years old, described in his poem about a Rembrandt painting. This work was then in the collection of the Counts Stroganov in St. Petersburg and the young man was suddenly inspired and saw the image of the heroes who populated his own world and his imagination. In his eyes, this painting is an incarnation of "the great mystery of art" and the even more inaccessible mystery of his own destiny. The poet describes the "sombre genius" of the painter and identifies with the passion and sufferings of the artist and his loneliness in the world.

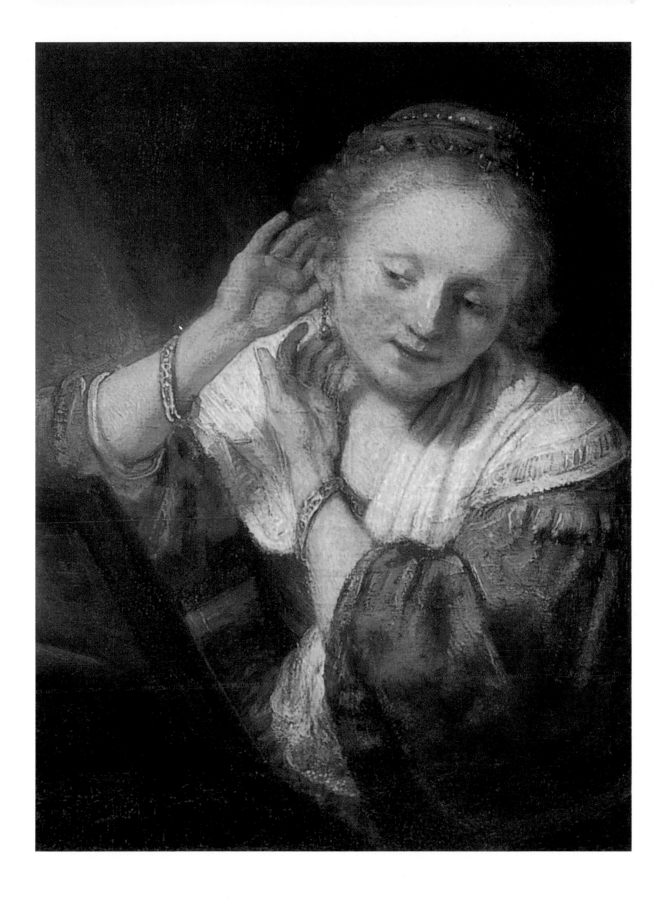

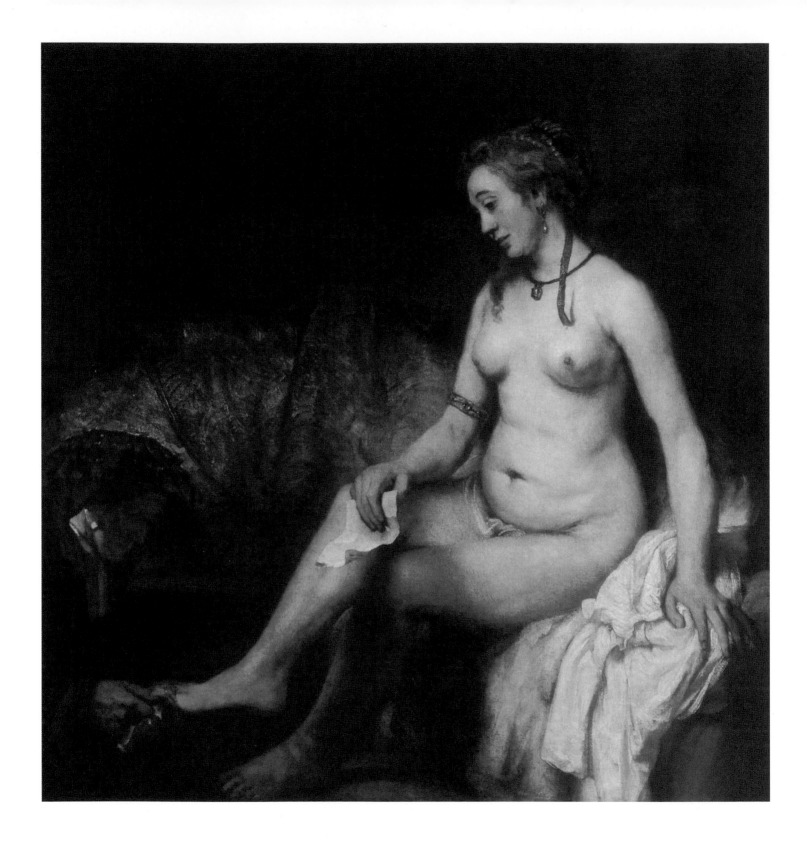

The artist's philosophy, his subjective vision of the world are those of a convinced sceptic. The tragedy inherent in Rembrandt's last paintings is generally explained by the adversity he had suffered, and the painful solitude he had experienced as an artist. Saskia's death and the subsequent death of Titus in 1668 certainly affected him deeply since he was very sensitive and all that he felt in his heart is reflected in the faces of his figures. The economic crisis in the Low Countries, as well as his own financial difficulties also decisively affected his work. Yet it was not so much the outside influences as his own innermost nature which he was painting in the shadow and light of his good and bad days. In Rembrandt, even happiness had its own colour but it was the colour of melancholy. Even the two women who had done something to brighten his son's existence after Saskia's death – Hendrickje Stoffels from 1649 until her death in 1663, then Magdalen van Loo after 1668 – did nothing to change his vision of mankind. There is evidence of its in his early work, and his later works only reinforced his attitude. Rembrandt Harmen Gerritszoon van Rijn died on 4 October, 1669, leaving more than six hundred paintings and an impressive series of etchings. There were portraits, religious subjects, landscapes and genre scenes. The paintings which can be seen in the Russian museums give a clear idea of his art because the collection summarises his life's work and the manner in which it evolved. The portraits show the brilliance of his art and the variety of subject-matter in his historic paintings show the diversity of approach. Rembrandt's work, which is so strongly personal, occupies a unique place not only in painting but in the whole of European culture. When Rembrandt is compared with his predecessors or even with his successors, one can see the total originality of his creativity and can precisely measure the place he occupies in our spiritual heritage. Tsar Peter the Great brought the first Rembrandt's to Russia. He first had the idea in 1697 during his first trip abroad. Yuri Kologrivov visited The Hague in 1715 and returned with 43 paintings to be used to adorn the Palace of Montplaisir at Peterhof, which was then still under construction. But his task was not complete, since he then travelled successively to Antwerp and Brussels, finally acquiring 117 other paintings by Amsterdam's Old Master. At the same time, the ambassador Kuranin and commercial attaché Soloviov were entrusted with a similar mission. The result was that in the following year, 150 paintings entered the Russian collections. This was a period during which Rembrandt's paintings were considered to be either "heretical" or old-fashioned. They rarely came up for public auction and when they did so they fetched derisory sums. The first paintings were hung in the Hermitage in 1764, less than 100 years after the artist's death. They represented a lot of 225 paintings, consigned by a merchant from Berlin as part-payment of a debt which he owned to the Imperial treasury.

51. *Bathsheba at her Bath*, 1654, Louvre, Paris.

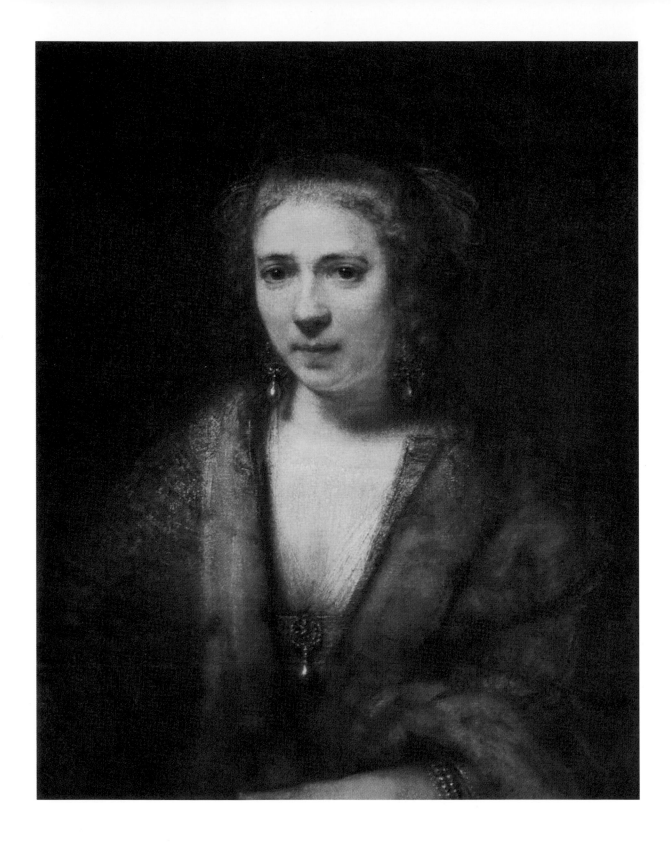

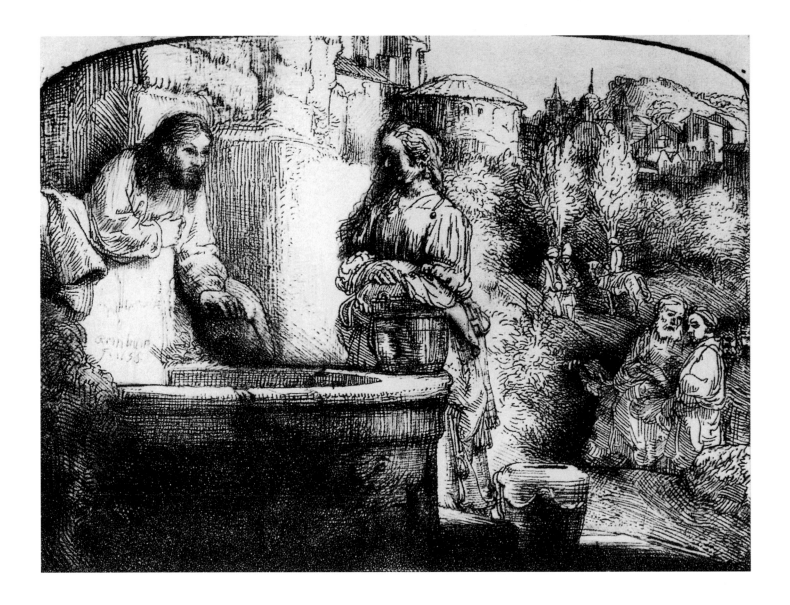

Prince Golytsin, the charge d'affaires in Paris, and a friend of Diderot and Falconet, also played a very active part in the adornment of the new art gallery. Two major works now in the Hermitage owe their presence to his endeavours. These are *Portrait of An Old Woman in Spectacles* and *The Return of the Prodigal Son*. In St. Petersburg, Rembrandt continued to enjoy a high reputation. The Imperial Russian court showed great enthusiasm for the work of the Dutch Master who had no equal in western Europe where his works continued to be regarded at best with indifference, at worst with disdain. For instance, in 1772 Falconet wrote as follows to Catherine II: "I received notice from France that there is a perfectly beautiful Rembrandt painting available which makes a pair with the Prodigal Son.

52. ***Hendrickje Stoffels***,
Louvre, Paris.

53. ***Christ and the Samaritan Woman***,
1658. Etching.

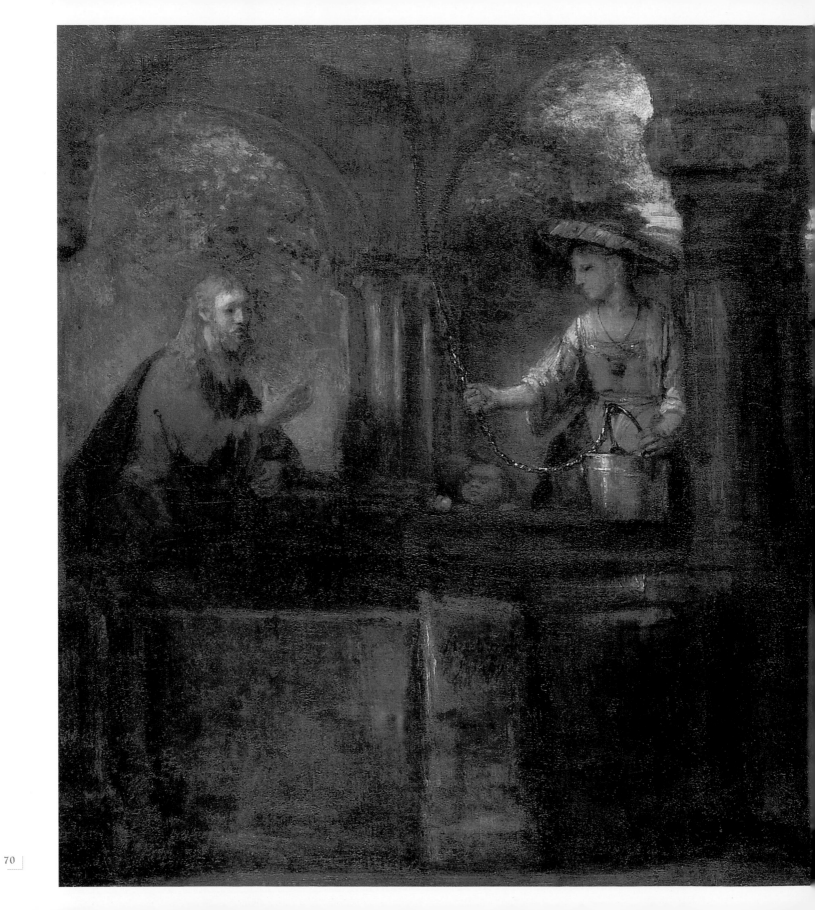

54. ***Christ and the
Samaritan Woman***,
1659. Oil on canvas,
restretched,
60 x 75 cm, restored,
St. Petersburg,
Hermitage

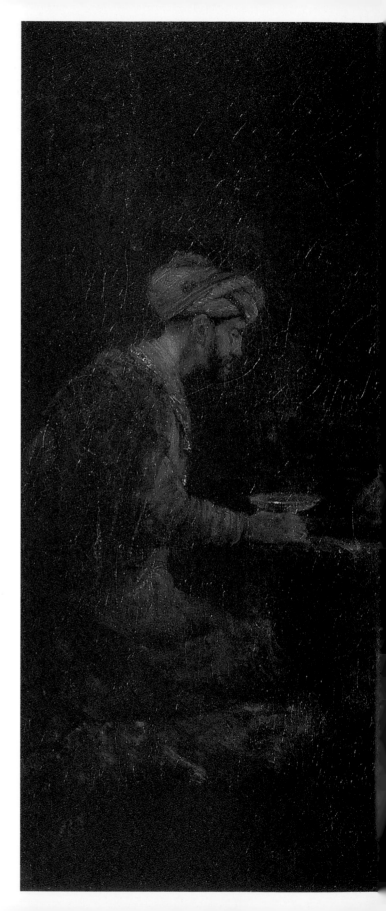

55. *Haman, Esther and Ahasuerus*. 1660.
Oil on canvas,
restretched, 73 x 94 cm,
Pushkin Museum of
Fine Arts, Moscow.

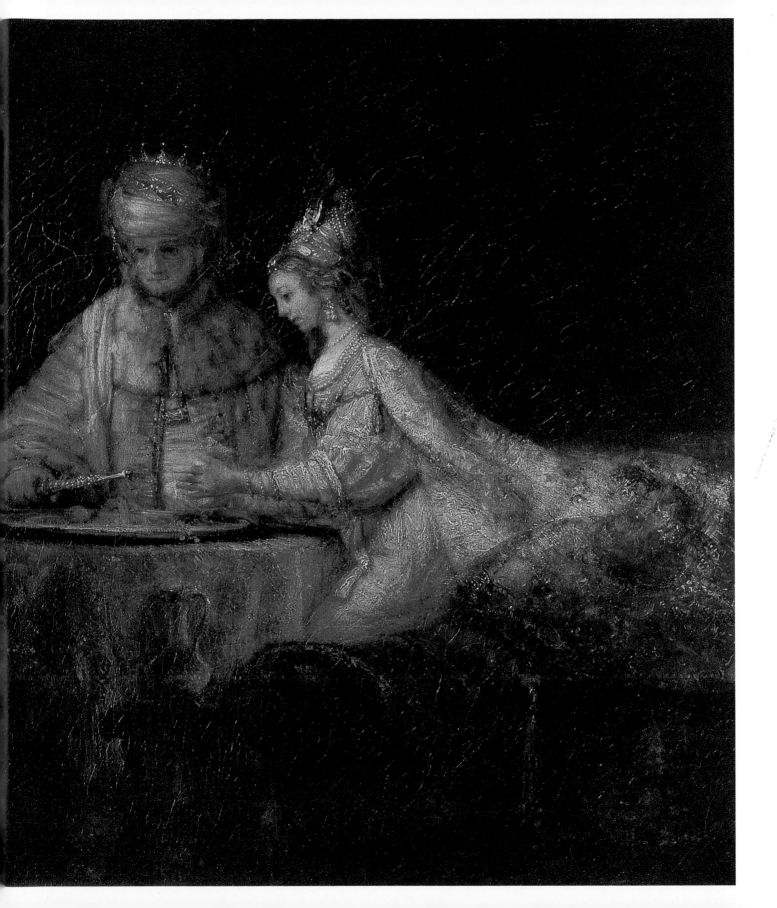

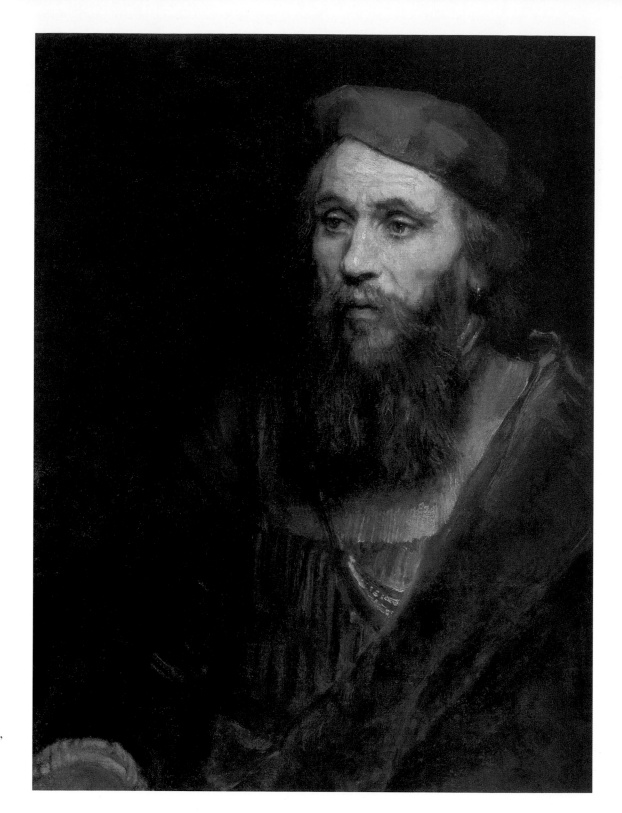

56. ***A Bearded Man***,
 1661, oil on canvas,
 71 x 61 cm,
 St. Petersburg.
 Hermitage.

57. ***Aristotle in front of
 Homer's Bust***, 1653,
 Metropolitain
 Museum of Art,
 New York.

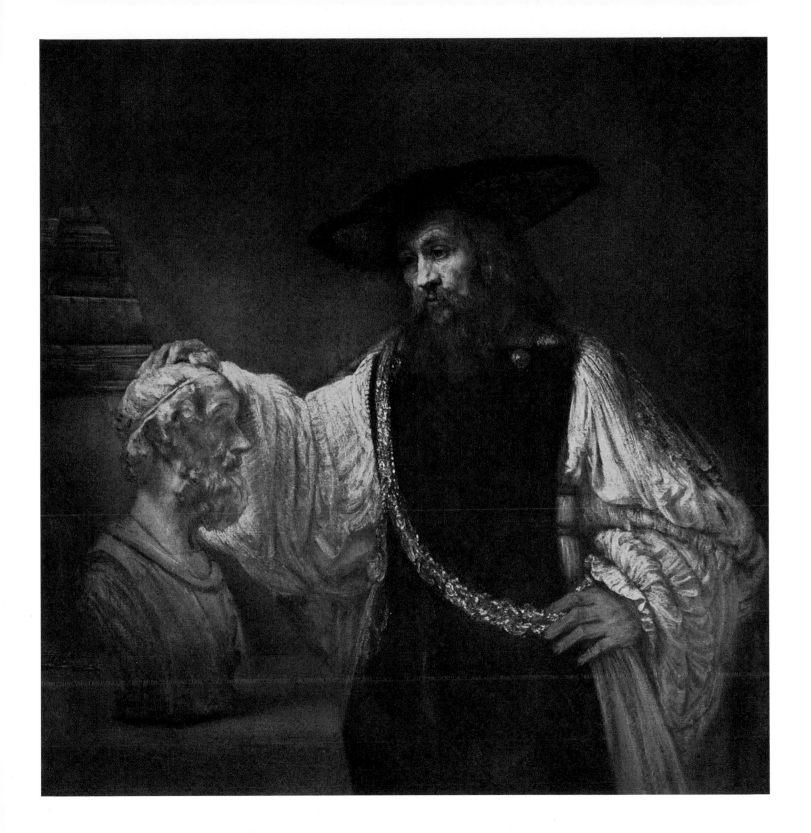

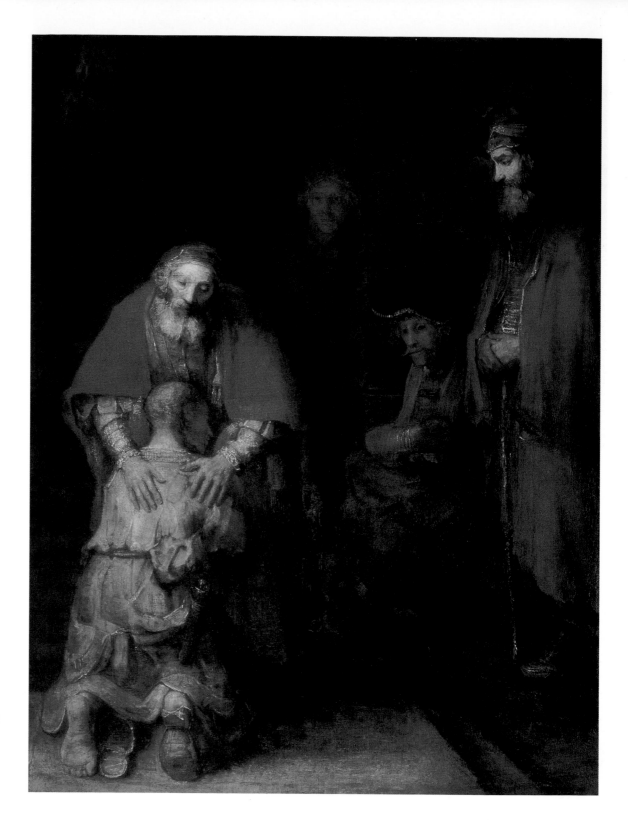

58. ***The Return of the
 Prodigal Son***. Oil on
 canvas, restretched,
 262 x 205 cm,
 St. Petersburg.
 Hermitage.

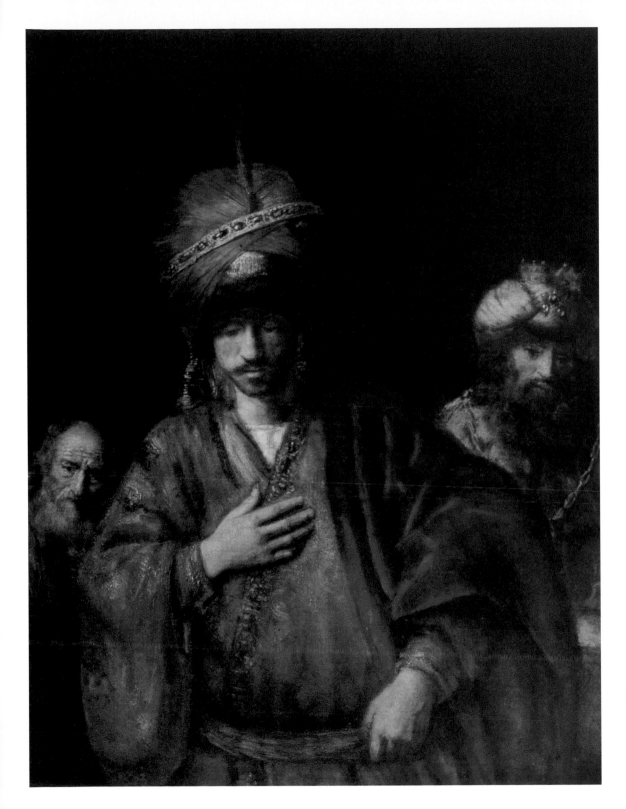

59. ***David and Uriah***,
 1665. Oil on canvas,
 restretched,
 127 x 116 cm,
 Hermitage,
 St. Petersburg.

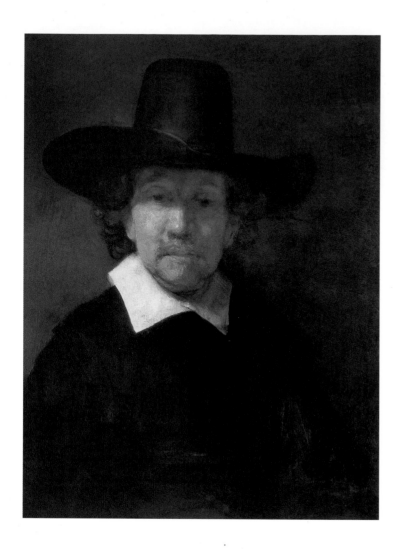

60. ***Portrait of the Poet Jeremiah de Decker***,
1666. Oil on wood
(oak), increased,
71 x 56 cm,
Hermitage,
St. Petersburg.

If it really is as good as that, then this item would be worthy of your gallery. If your Imperial Majesty should command me to do so, I shall write to one of our best artists to go and see the painting and to judge whether it is as good as it is reported to be; because I am very wary of giving this task to any others. The subject is Mordecai at the feet of Esther and Ahasuerus. The price is three thousand six hundred pounds".

Shortly thereafter, Catherine replied to Falconnet that if the painting was as good as her *Prodigal Son* she would be happy to pay that price. In fact, the sale never proceeded, although the painting remained in Paris for 15 years without finding a purchaser. Today it adorns the walls of the Bucharest Museum.

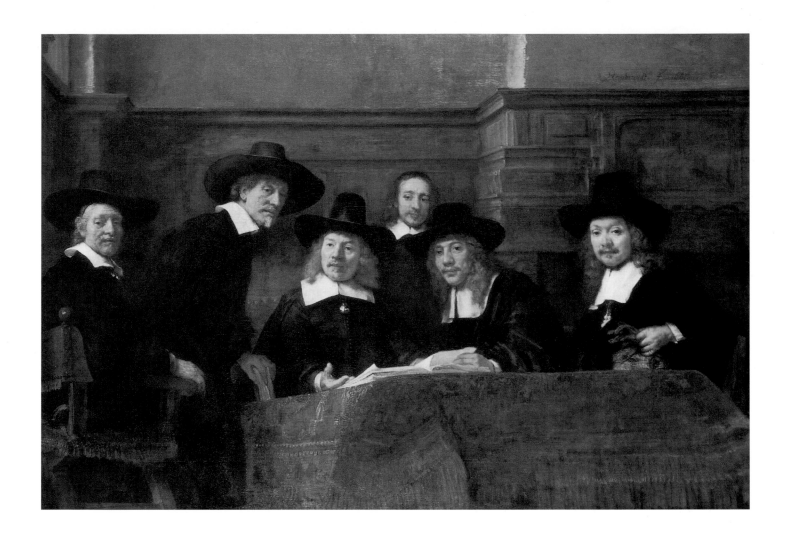

In 1769, after several years of legal battles, the collection of Count Heinrich Brühl, former minister of Augustus III of Saxony, was acquired by the Hermitage. Among the treasures amassed by the count and his secretary, who was the curator of the Print Room of Dresden and an informed art critic, there were four Rembrandts, *Portrait of an Old Man* and *Portrait of an Old Man in Red* now in St. Petersburg, as well as *Portrait of Adriaen van Rijn* and *Portrait of an Old Woman* which are now in the Pushkin Museum in Moscow. *David and Uriah, Flora, Danaë* and *The Sacrifice of Abraham* are among numerous acquisitions made throughout the 18th century, after the deaths of many great foreign collectors.

61. *The Syndics of the Drapers*, 1662. Rijksmuseum, Amsterdam.

LIST OF ILLUSTRATIONS

BEHIND THE NEWS

THE NEWS

RACE AND CRIME

Philip Steele

WAYLAND

First published in 2014 by Wayland
Copyright © Wayland 2014

Wayland
338 Euston Road
London NW1 3BH

Wayland Australia
Level 17/207 Kent Street
Sydney, NSW 2000

All Rights Reserved.
Produced for Wayland by Tall Tree Ltd
Editors: Emma Marriott and Jon Richards
Designer: Malcolm Parchment

ISBN 978 0 7502 8256 7
E-book ISBN 978 0 7502 8817 0

Dewey number: 364.2'56-dc23

10 9 8 7 6 5 4 3 2 1

Printed in China

Wayland is a division of Hachette Children's
Books, an Hachette UK company
www.hachette.co.uk

The publisher would would like to thank the
following for their kind permission to reproduce
their photographs:

Shutterstock.com unless stated otherwise:
Front cover: Digital Storm , © Turkbug ,
© Americanspirit
© REBECCA COOK/Reuters/Corbis (4),
© JOSHUA LOTT/Reuters/Corbis (5), redfrisbee (6),
Public domain (7), © Chrisharvey (8 – posed my
model), michaeljung (9), Getty Images (10), Ira Bostic
(11), Peter Kim (12), Constantine Pankin (13), Clive
Chilvers (14), © Matthew Aslett/Demotix/Demotix/
Demotix/Corbis (15), REX/Gavin Rodgers (17)
© Americanspirit (19), Public domain (19) David P.
Lewis (20), 360b (21), REX (22), REX (23), © Ryan
Beiler (24), Kostas Koutsaftikis (25), © Angela
Ravaioli (26), Ryan Rodrick Beiler (27), Public
domain (28), bikeriderlondon (31), Public domain (32),
Carl Stewart (33), © FELIX ADLER/epa/Corbis (34),
Zoran Karapancev (35), Sam DCruz (36), Everett
Collection (37), Leonard Zhukovsky (38), a katz
(39), © NIR ELIAS/Reuters/Corbis (40), Natursports
(41), © Digikhmer (42), s_bukley (43), lcswart (45)

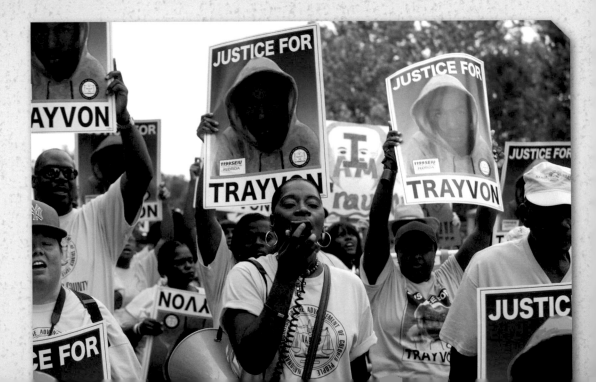

CONTENTS

RACE, CRIME AND THE LAW

In 2013, Renisha McBride had a car crash in Detroit, USA in the early hours of the morning. She was a 19-year-old African-American who had drunk over the limit and clipped a parked car. She went to a nearby house for help, knocking on the screen-door. Theodore Wafer, a 54-year-old white man, came to the porch.

Questions of colour?

Instead of helping Renisha, Wafer shot her in the face and killed her. He said the shooting was an accident and that he had feared she was breaking in.

Wafer was charged with second-degree (non-premeditated) murder. Renisha's family and many campaigners believed that racism must have played a part in this killing.

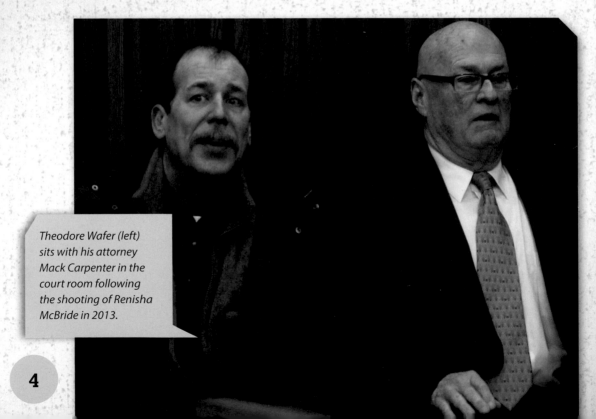

Theodore Wafer (left) sits with his attorney Mack Carpenter in the court room following the shooting of Renisha McBride in 2013.

4

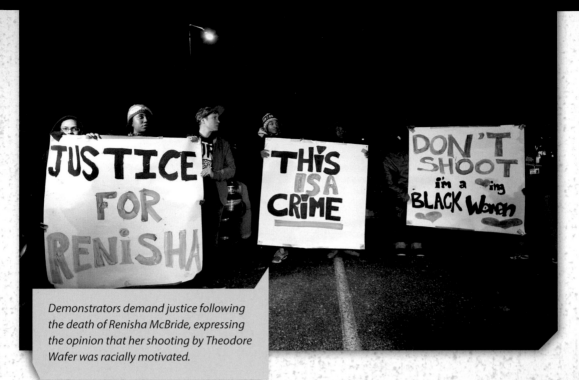

Demonstrators demand justice following the death of Renisha McBride, expressing the opinion that her shooting by Theodore Wafer was racially motivated.

What is racism?

Racism is the belief that human beings are divided by race and that some races are superior to others. The county prosecutor Kym Worthy, also an African-American woman, said that race was not a consideration in the legal charges brought against Theodore Wafer. A public debate began. Why would someone assume that a young black person was a criminal? Was the killing motivated by hatred or by fear based on the colour of their skin?

Wider issues

The Renisha McBride case was not a one-off. In fact, news headlines often link the issues of race and crime. The aim of this book is to find out more about stories in the news and to question some assumptions. Are some crimes carried out by one ethnic or racial grouping more than by others? What about policing, poverty, prisons, immigration and the media? Hatred, abuse and terrible crimes, such as slavery and genocide, are all linked to race. Who are the perpetrators and who are the victims?

'... there is a history of racial disparities in the application of our criminal laws, everything from the death penalty to enforcement of our drug laws. And that ends up having an impact in terms of how people interpret the case.'

US President Barack Obama, 2013.

RACISM IN HISTORY

Ever since humans have existed, they have moved around the world, encountering other populations and mixing with them. Sometimes, this has led to tension or violence. The economics of slavery and empire in the 1700s and 1800s encouraged many whites to emphasise differences between races.

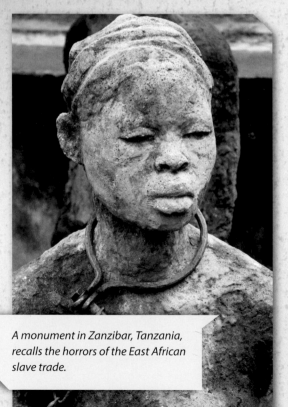

A monument in Zanzibar, Tanzania, recalls the horrors of the East African slave trade.

• *In Roman times, Europe was multi-ethnic. African soldiers were stationed on Hadrian's Wall, in northern England, back in 208 BCE. The Roman Empire relied on slavery, but this was not based on race.*

• *Anti-Semitism, which is prejudice or hatred towards Jews and their religion, was common in medieval Europe. Mass-murder of Jews took place in Norwich and York in 1190. Jews were expelled from England in 1290, from France in 1394 and from Spain in 1492.*

• *Across Europe from the 1300s to the 1600s, foreign workers were often killed by angry mobs. An irrational fear of strangers is called xenophobia.*

- The African slave trade grew rapidly in the 1500s. Until the 1800s, European countries shipped millions of Africans across the Atlantic in awful conditions.

- Even after slavery was abolished (in the British Empire in 1833 and in the United States in 1865), former slaves and their descendants often suffered from poverty and discrimination in the criminal justice system.

- The empires of the 1700s and 1800s encouraged Europeans to regard Asians and Africans as inferior races. Some native peoples in North and South America and Oceania were victims of genocide by white settlers.

- From the 1860 onwards, there was a widespread belief that human biology predetermined criminal behaviour. Pseudo-scientists (those who claim that their theories are scientific without scientific evidence) claimed that both lower social classes and non-whites were 'less evolved' than upper-class whites, and were therefore more likely to become criminals.

- These ideas inspired white supremacists such as the Ku Klux Klan in the United States (re-established 1915) and the Nazi Party (established 1920) in Germany. From 1933 to 1945, the Nazis murdered millions of Jews, Slavs and Roma in extermination camps.

- The years after 1945 saw the rise of a civil rights movement in the United States. Apartheid laws segregated races in South Africa from 1948 to 1994.

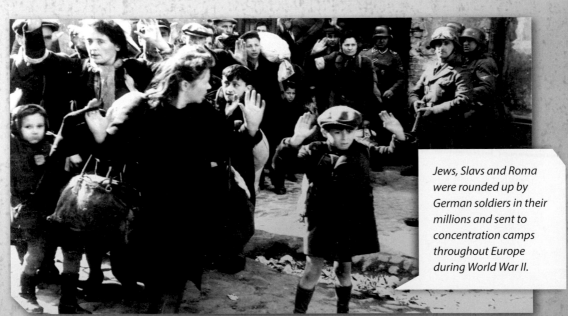

Jews, Slavs and Roma were rounded up by German soldiers in their millions and sent to concentration camps throughout Europe during World War II.

MYTHS, FACTS AND FIGURES

Every new-born baby looks different. Each is the result of hundreds of thousands of years of evolution and successful adaptation to global environments. This has resulted in a variety of skin and hair colours, facial features and body types. People use these differences in appearance to define 'races'.

The meaning of race and crime?

All humans are members of the same species. Genetic differences between the groups of humans are tiny. 'Race' is not a very meaningful term scientifically. It is one of the many ways in which humans have decided to classify each other.

The 19th-century idea linking some races to criminal behaviour is nonsensical – doubly so, because ideas of race and criminal behaviour vary with geography and time. The ideas of race and crime are not eternal truths, but are made up in response to varying situations.

The ethnic make-up of many cities is very diverse, as shown by the racial mix of these spectators at the River Thames Festival, London.

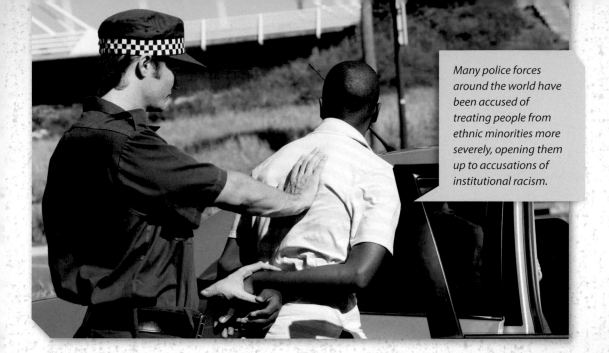

What is ethnicity?

An individual ethnic group is made up of a group of people who share common descent. They may also share a culture, language, religion or specific customs. People are not born with these values or practices. Instead, they learn them as they grow up. Within any ethnic group, individual people may hold many different values and beliefs. A general blanket condemnation of any one ethnic group as having criminal tendencies is a form of racism.

Crime figures

News headlines often stoke up fears of crime. Although such fears may be unfounded, they often lead racists to blame whole communities. Fortunately, detailed statistics for both ethnicity and crime are available these days, so facts and figures should shed some light on any problems that really exist. These statistics should show if any ethnic groups are disproportionately represented in any areas of crime, as perpetrators or victims, or in terms of arrests and sentencing.

'So peace does not mean just putting an end to violence or to war, but to all other factors that threaten peace, such as discrimination, such as inequality, poverty.'

Aung San Suu Kyi, Nobel Peace Prize winner.

FLORIDA, USA, 2012

Trayvon Martin was a 17-year-old African-American. He lived in Miami Gardens, Florida, with his mother and elder brother. His parents were divorced and his father's new partner lived in Sanford. On 26 February 2012, Trayvon and his father were visiting her home in a gated housing complex called The Retreat.

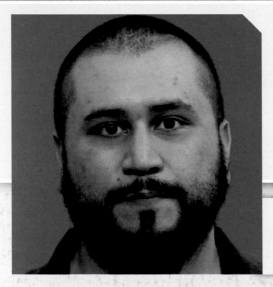

NEWS FLASH

Location: Sanford, Florida, USA
Date: 26 February 2012
Incident: Homicide
Perpetrator: George Zimmerman (aged 28, left)
Victim: Trayvon Martin (aged 17)
Outcome: Acquittal

In July 2013, George Zimmerman was acquitted of all charges in the shooting of Trayvon Martin.

Suspicion

George Zimmerman, 28, also lived in The Retreat. He was described as Hispanic, being part Peruvian. Tensions in the neighbourhood were running high, as there had been a number of burglaries in the area. George was a neighbourhood watch representative and according to police and newspaper reports, he regularly called the police if he saw anyone he thought looked suspicious. Driving his car around the complex that evening, Zimmerman saw Martin coming back from the local shop. He called the

police because he thought Martin might be 'up to no good'. Against advice from the police, Zimmerman followed Martin and confronted him. A fight followed. Zimmerman shot Martin dead with a legally owned pistol – the teenager was unarmed. George Zimmerman was arrested, but released after just five hours. Although it was Zimmerman who had pursued Martin, police said there was no evidence that he was not shooting in self-defence. This was legal under Florida's controversial 'Stand Your Ground' law, which allows individuals to defend themselves with deadly force in certain situations.

A racist killing?

The Trayvon Martin case caused outrage across the United States and accusations of racism. Could an unarmed African-American teenager be shot dead just because someone else thought he looked suspicious? Had nothing changed?

The Florida governor stepped in and appointed a special prosecutor, who laid charges of second-degree murder and manslaughter against George Zimmerman.

In July 2013, a jury acquitted George Zimmerman. Some people were satisfied that the letter of the law had been followed, but many others felt an injustice had been done.

> **'You can stand your ground if you're white, and you can use a gun to do it. But if you stand your ground with your fists and you're black, you're dead.'**
>
> David Simon, creator of *The Wire* television series, 2013.

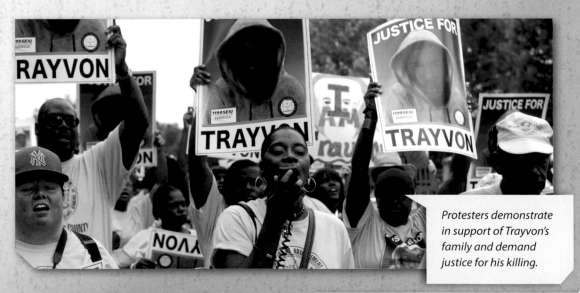

Protesters demonstrate in support of Trayvon's family and demand justice for his killing.

HOW USEFUL ARE STATISTICS?

Census statistics and crime surveys provide useful information. They identify all sorts of social problems and help decide strategies for crime prevention and policing. Statistics for ethnic background are often included in the data.

Checking the figures

To interpret statistics, we need to read the small print and find out which methods were used to gather them. To make comparisons, we must know if crimes have been defined in the same way. Are police methods of recording crimes standardised? Are the ethnic categories sometimes too broad to be meaningful? For example 'Asian', 'White' or 'Hispanic' could all include very varied groups of people. Is the selection of crimes in the statistics very limited, referring to street crimes linked to poverty, for example, but excluding corporate tax evasion? It is important to look at the bigger picture, too. Is the overall crime rate falling or rising?

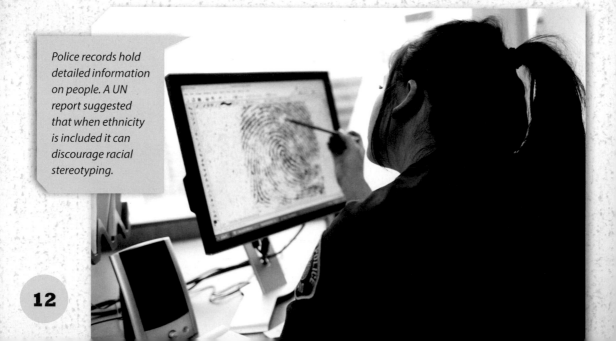

Police records hold detailed information on people. A UN report suggested that when ethnicity is included it can discourage racial stereotyping.

DEBATE

Should we focus on a racial group because of what the statistics say?

YES

Focusing on a racial group that statistically is shown to commit certain crimes will stop crimes before they happen.

NO

Focusing on a specific group is unfair. There are other factors, such as income or social class that may be more important.

One of many factors

Many statistics do show a clear correlation between ethnicity and crime. This does not mean that one is the cause of the other, although any disproportion in the statistics is of course important evidence. Many other factors enter the equation. These might include poverty, social class, education, age, gender, integration into society, or wider political contexts. Is there a danger that in looking at crime with too much focus on race, we might be missing other important clues? If migrant workers commit crimes, should we be looking at their ethnicity or at their marginal social status or poverty?

A high conviction rate suggests that more people from one ethnic group are guilty, but that might be misleading – for example, in some instances one group may have access to better defence lawyers than another. Is the criminal justice system even-handed, or are prejudiced police, courts or juries coming down too heavily on one particular group, and therefore skewing the statistics?

CRIMINAL JUSTICE STATISTICS

Here are just a few statistics found in a 2012–13 report on the Race and Criminal Justice System in England and Wales:

- Racially or religiously aggravated offences were down by 20.5 per cent (2008–13).
- A black person was six times more likely to be stopped and searched by police than a white person.
- A black person was nearly three times more likely to be arrested than a white person. A person of mixed race was twice as likely to be arrested.

POLICING AND PROFILES

The police are there to prevent crime and enforce the law. By its very nature, policing is a difficult and challenging job. It has varied greatly over the years and from one nation to another. The way in which the police treat social and ethnic minorities tests the democratic credentials of any society.

Police and community

The police are sometimes seen as a community-based force, made up of regular citizens acting on behalf of the public. Officers need to know people on the street and understand all sections of the community. Speeding patrol cars and surveillance cameras may be necessary to prevent crime, but they are not features that hold a community together.

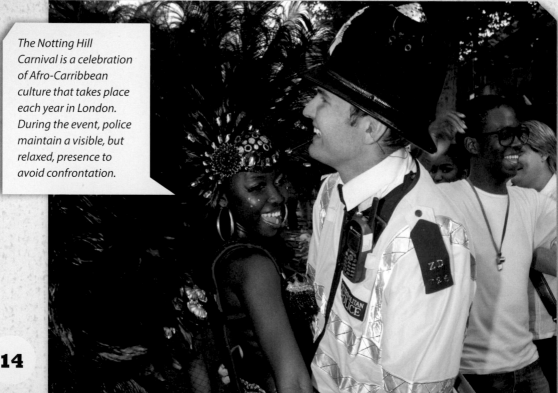

The Notting Hill Carnival is a celebration of Afro-Carribbean culture that takes place each year in London. During the event, police maintain a visible, but relaxed, presence to avoid confrontation.

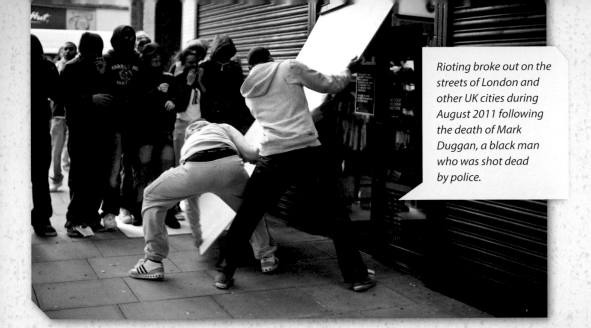

Rioting broke out on the streets of London and other UK cities during August 2011 following the death of Mark Duggan, a black man who was shot dead by police.

A war against crime

In some countries police forces act more as political agents of the state, taking part in a 'war' against crime. If the police take on gangs or organised crime, things can turn violent. 'Hard' policing may be needed, but it will not be effective unless it is fair and transparent. Over-authoritarian or corrupt policing can be counterproductive, especially if members of the force, like members of the public, include racists.

The mindset that automatically categorises certain sections of society as a dangerous underclass soon breeds resentment. It criminalises innocent people. In the suburbs of big cities, one spark can set off a riot that can leave both

'A riot is the language of the unheard.'

Dr Martin Luther King Jr.

public buildings and community relations in smouldering ruins.

In the UK, these issues have been at the forefront of debates about policing since 1981. They were discussed in the Scarman Report, following a riot in Brixton, south London. Lord Scarman pinned the blame on 'complex political, social and economic issues'. He highlighted the police's lack of consultation with the community, excessive 'stop-and-search' campaigns and the presence of racists in the ranks.

'... an outburst of anger and resentment by young black people against the police...'

The Scarman Report into the Brixton riots in London in 1981.

STOCKWELL, UK, 2011

Many poor city districts have a violent youth culture. In Stockwell, south London, there were two gangs fighting to control the district. The GAS gang dealt in drugs, took part in robberies and carried weapons. They were out to get their rivals in the ABM gang.

NEWS FLASH

Location: Stockwell, London, UK
Date: 29 March 2011
Incident: Shooting
Perpetrators: Nathaniel Grant (aged 21), Antony McCalla (aged 19), Kazeem Kolawole (aged 19)
Victims: Thusha Kamaleswaran (aged 5, left) and Roshan Selvakumar (aged 35)
Outcome: Victims survived. Life sentences for perpetrators.

Since the shooting, Thusha has regained some feeling in her legs and is able to take a few steps.

Gang crime

Three young black men, Nathaniel Grant, Kazeem Kolawole and Antony McCalla, were chasing a rival gang member named Roshaun Bryan. Cycling down the street, they fired guns into a small grocery and off-licence store. They missed their intended victim, but hit a bystander named Roshan Selvakumar and a little girl named Thusha Kamaleswaran, who was playing in her uncle's shop. They were both Asians, from Sri Lankan families.

A bullet to the spine

Roshan was hit in the head by a bullet but survived. Thusha's bullet passed through her chest and entered her spine. Her heart stopped twice but she was saved by paramedics. She was paralysed and had to learn to use a wheelchair. Thusha was told she would never walk again, but two years later, she managed some steps. Police officers raised charity money to support Thusha's treatment.

Brought to justice

Footage from surveillance cameras in the area identified the attackers. They were arrested, found guilty and received life sentences – Grant was sentenced to serve no fewer than 17 years, while the other two attackers were sentenced to no fewer than 14 years in prison.

'... an attack on society itself by men who saw themselves as outside the law and above the law.'

Judge Martin Stephens QC presiding over Thusha Kamaleswaran's case.

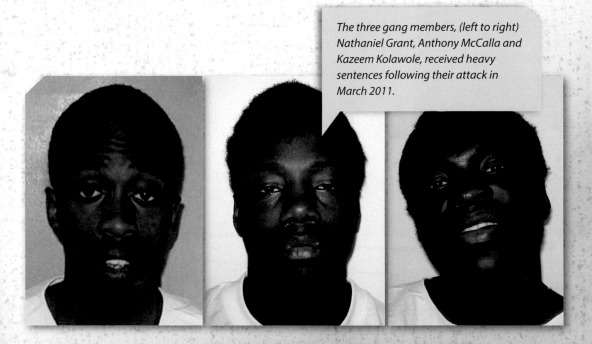

The three gang members, (left to right) Nathaniel Grant, Anthony McCalla and Kazeem Kolawole, received heavy sentences following their attack in March 2011.

'Respect. You don't need a gun to get it.'

Campaign message by Olympic boxer James de Gale, singer Estelle and television's *The Apprentice* winner Tim Campbell, through Trident, the partnership between the Metropolitan Police force and London's black communities.

DOES 'STOP AND SEARCH' WORK?

If statistics demonstrate that ethnicity plays a role in certain criminal activities, does it make sense for police officers to pull over people from those ethnic groups and question them? Such activity is called racial profiling, and in some countries it is illegal. Why?

Racial profiling

It is difficult to fight one injustice (such as knife crime) with another injustice (such as racial profiling). Without genuine grounds for suspicion, it cannot be acceptable to stop people just because of their racial appearance. That relies on a kind of prejudgement, or prejudice. Racial profiling encourages thinking in terms of racial stereotypes and it gives any racist officers the opportunity to harass minorities on the street.

DEBATE Is 'stop and search' effective'?

YES

It makes a difference. In 2013, a New York judge banned a 'stop and frisk' programme as being racist and unconstitutional. In the month that followed, illegal shootings were up by nearly 13 per cent and gun seizures fell by nearly 20 per cent.

NO

In the UK, about 1.2 million people a year are stopped or searched by the police, on average for 16 minutes at a time. However, only nine per cent of those stops actually lead to arrests, let alone convictions. It is not the best use of police time and alienates many innocent people.

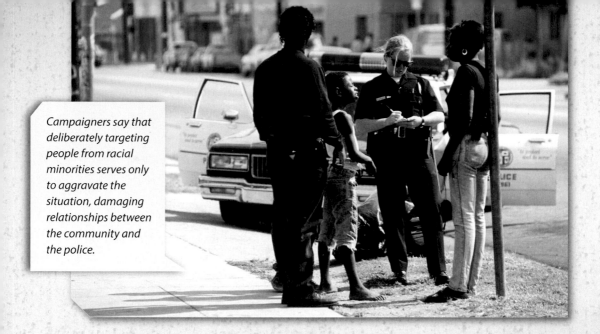

Campaigners say that deliberately targeting people from racial minorities serves only to aggravate the situation, damaging relationships between the community and the police.

Counter-productive?

As tempers fray, community relations are damaged. Racial profiling has often been blamed for triggering city riots. African-American comedians have joked that there must be a crime called 'driving when black', judging by the number of times the police stop African-Americans.

Checks and balances

In the UK, the Police and Criminal Evidence Act (PACE) was brought in to regulate the balance between police powers and public freedoms. It states that a police officer must have reasonable grounds of suspicion for stop and search. It also states that the person stopped has the right to complain. Campaigners say these are useful checks, but the possibility that some officers might abuse the system cannot be ruled out.

Concerns may also be extended to other areas of policing. Proposed immigration laws may encourage members of the public, such as landlords, to use racial profiling in reporting people they suspect of being illegal immigrants to the police.

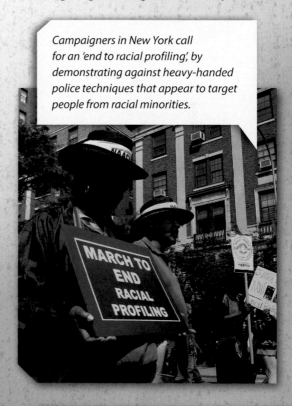

Campaigners in New York call for an 'end to racial profiling', by demonstrating against heavy-handed police techniques that appear to target people from racial minorities.

CRIMES OF HATRED

Considerations about race can be applied, whether appropriately or not, to any type of crime. However, some crimes are bred in those notions of difference that are at the root of racism itself. They consist of public hatred and racial abuse.

Racist attack

At one end of the spectrum are everyday incidents of rudeness, contempt, exclusion and bullying. Disparaging 'jokes' might seem to be a petty matter, but to the person on the receiving end, day after day, they can become depressing and humiliating. Verbal abuse may become brutal physical abuse, a vicious racist attack may become a murder. The most notorious racial murder in modern Britain took place in London in 1993. Stephen Lawrence, a black teenager, was attacked and stabbed to death at a bus stop. It was 2011 before two men were convicted of the crime, after changes to the law, reviews of policing and a major public inquiry.

Members of the Tamil community in Ottawa, Canada in 2013 call for an end to attacks against Tamil citizens in Sri Lanka.

Crimes against humanity

Horrific crimes such as people trafficking, sex trafficking, work exploitation and slavery may be based on race or ethnicity. In such cases, the victim is regarded as inferior or as a commodity to be exploited, rather than as an equal human being.

The worst racial crimes of all are known quite rightly as crimes against humanity.

They include 'ethnic cleansing' – a hateful term first used in Serbia in 1992. It means the enforced removal of a whole ethnic group from a territory by destroying their homes, intimidating them by rape, violence, deportation and murder.

Worst of all is genocide – the deliberate eradication of thousands, or millions, of people because of their ethnicity.

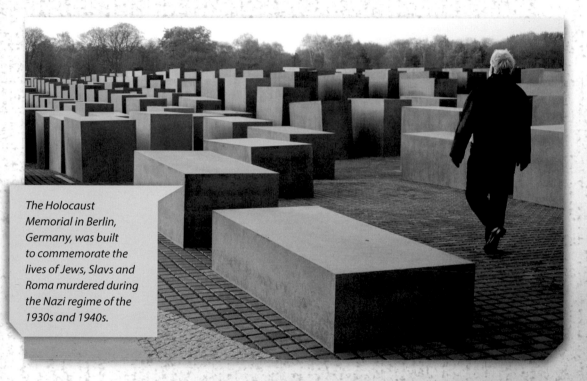

The Holocaust Memorial in Berlin, Germany, was built to commemorate the lives of Jews, Slavs and Roma murdered during the Nazi regime of the 1930s and 1940s.

'No one is born hating another person because of the colour of his skin, or his background, or his religion. People must learn to hate, and if they can learn to hate, they can be taught to love, for love comes more naturally to the human heart than its opposite.'

Nelson Mandela in his autobiography, *Long Walk to Freedom* (1994).

BIRMINGHAM, UK, 2013

Pavlo Lapshyn from Dnipropetrovsk in Ukraine was a PhD student at Ukraine's National Metallurgy Academy. In 2011, he won a competition for a sponsored work placement with a firm in Birmingham. Little did his employers know that Lapshyn was a fascist, a white supremacist with a hatred of all Muslims.

NEWS FLASH

Location: Birmingham, UK
Date: 29 April 2013
Incident: Homicide and bombing
Perpetrator: Pavlo Lapshyn (aged 25, left)
Victim: Mohammed Saleem (aged 82)
Outcome: Convicted

After Pavlo Lapshyn's conviction for crimes motivated by religious and racial hatred it emerged that his grandmother had been brought up as a Muslim.

Mission of hatred

Lapshyn took a flat in the Small Heath district of Birmingham. Just five days after arriving, he followed Mohammed Saleem, a much-loved grandfather, as he left the mosque after evening prayers. Lapshyn stabbed the 82-year-old man to death a few yards from his home. The crime was recorded on a surveillance camera, but the image of the killer was not very clear and the attacker was hard to identify.

In June and July 2013, Lapshyn placed three homemade bombs outside mosques – one in Walsall, one in

> '**My Dad was a well-loved man. He was respected by everyone in this community... We all have the right to feel safe and nobody should have to go through this... It is just unbearable, unbelievable.**'

Shazia Khan, Mohammed Saleem's daughter, on BBC News.

Mohammed Saleem was the victim of a murderous attack by racist killer Pavlo Lapshyn.

Wolverhampton and one in Tipton. The first two caused no injuries but the third bomb had been packed with nails. If the time of prayers had not been changed that day, the blast could have been deadly.

A life term

The police finally traced the crimes back to Pavlo Lapshyn. Equipment and computer files found in his flat showed that he was a bomb-maker and racist, who also played a computer game called *Ethnic Cleansing*. In October 2013, Lapshyn was sentenced to life imprisonment with a minimum term of 40 years for the murder of Mohammed Saleem and for plotting to cause the explosions at the mosques.

> '**You were motivated to commit the offences by religious and racial hatred, in the hope that you would ignite racial conflict.**'

The Honorable Mr Justice Sweeney presiding over Lapshyn's case.

WHAT CAUSES RACIST CRIME?

Racist crime is often the result of a lack of understanding. Ignorance can lead to fear and anger, and even simple differences can cause friction. Migrants may keep themselves apart from communities they settle in, failing to learn the language or understand local customs.

Scapegoating the innocent

After terrorist attacks or during a war, ethnic communities may find themselves scapegoated for acts of violence that had nothing to do with them. This happened to many Asians and Muslims after the 9/11 attack in New York City in 2001. Racist crime cannot be prevented by legislation alone. Social barriers and mistrust must be broken down with communication, education and cooperation.

Fear of outsiders

What if people fear that immigrants will take their jobs? Economic rivalry is a common cause of ethnic tension and racist crime, even though immigration can actually be of benefit to an economy.

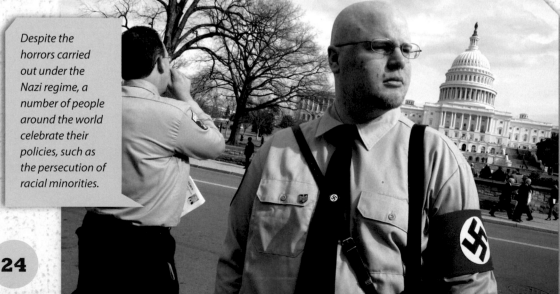

Despite the horrors carried out under the Nazi regime, a number of people around the world celebrate their policies, such as the persecution of racial minorities.

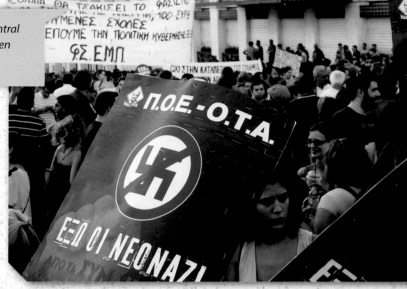

Greek students demonstrate in central Athens against the neo-Nazi Golden Dawn party in September 2013.

Throughout history, settled communities have feared nomadic peoples, such as the Roma in Europe, because of economic or cultural reasons.

Racist politics

Instead of trying to heal wounds, some political parties try to win power by playing on public fears and encouraging racist thuggery on the streets. In Greece, the neo-Nazi Golden Dawn party has attacked and murdered African and Asian immigrants and asylum seekers, often while the police stand by. In 2013, the Greek government declared the party a criminal organisation. However Golden Dawn had 21 seats in parliament, fairly won in an election. If the people freely elect racist criminals to represent them, how else might a democratic government respond?

'(Golden Dawn is) a criminal organisation that tried to cover itself under a political cloak.'

Simos Kedikoglou, spokesperson for the Greek government.

DEBATE

Do people have the right to make a racist speech in public?

YES

You may agree or disagree with what a speaker has to say, but freedom of speech should be protected by the law.

NO

Hate speech may incite violent crime and racists should not be given the chance of destroying community relations.

RACISM IN THE SYSTEM

A criminal justice system may target individual bigotry or the thuggery and violence of a racist political party. However, forms of racism can also be embedded in the whole political or legal system, in government, in education or healthcare, or in big corporations.

Collective failure

This kind of racism is called institutional racism. The term was first used in the 1960s by African-American activists. In the UK, it was defined by Sir William Macpherson in 1999 after the murder of Stephen Lawrence as 'the collective failure of an organization to provide an appropriate and professional service to people because of their colour, culture or ethnic origin'. Macpherson's chief concern was institutional racism within London's Metropolitan Police Service. He called for education and procedures to be revised to discourage racism, and for the recruitment of more officers from ethnic minorities.

Cécile Kyenge became Italy's first black minister in 2013. Since her appointment, she has faced a torrent of racist abuse from right-wing organisations and even from politicians in parliament.

Racism in government

Many countries have legislation in place to prevent institutional racism, however it is often treated lightly by the courts or ignored by individuals. Sometimes, whole areas of government policy are exclusive, restricting immigration or civil rights on grounds of race or religion.

Sometimes, racism forms the essence of government and law. This can be called constitutional racism. From 1948–94, the government of South Africa enforced a policy called apartheid – the segregation of society by race. The racist policies of Nazi rule in Germany from 1933–45, which resulted in the genocide of the Holocaust, were built into the governance of the nation. A racist constitution turns justice on its head, turning opponents of racism into criminals.

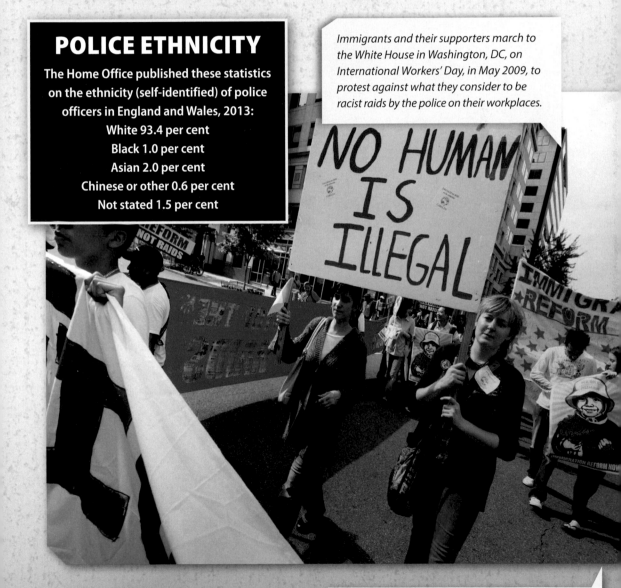

POLICE ETHNICITY

The Home Office published these statistics on the ethnicity (self-identified) of police officers in England and Wales, 2013:

White 93.4 per cent
Black 1.0 per cent
Asian 2.0 per cent
Chinese or other 0.6 per cent
Not stated 1.5 per cent

Immigrants and their supporters march to the White House in Washington, DC, on International Workers' Day, in May 2009, to protest against what they consider to be racist raids by the police on their workplaces.

DARWIN, AUSTRALIA, 2000

Australia has a long history of institutional racism. The greatest hardship has been experienced by Aboriginal Australians, for whom the coming of white settlers in 1788 meant loss of land, violence, discrimination, enforced resettlement and refusal of civil rights.

NEWS FLASH

Location: Darwin, Northern Territory, Australia
Date: 9 February 2000
Incident: Imprisonment
Issue: Custody of Aboriginal youth
Victim: 'Johnno' Warramarrba
Outcome: Suicide

The Don Dale Juvenile Detention Centre, where 'Johnno' Warramarrba killed himself.

Harsh laws

In the last 50 years, Aborigines have won back many of their basic rights, but still the penal system fails them. In the 1990s, mandatory sentencing was brought in to the Northern Territory and in Western Australia. Mandatory means that whatever the circumstances, the sentence must be applied. In Northern Territory, 75 per cent of those jailed under these laws were Aborigines, even though they made up 27 per cent of the population. Long prison sentences were handed out to Aboriginal youths for petty theft.

The death of 'Johnno'

'Johnno' Warramarrba was an Aborigine from Groote Eylandt, an island in the Gulf of Carpentaria, in the Northern Territory. The island is the location of the rich Gemco manganese mine, but local Aboriginal people live there in poverty. Johnno was a 15-year-old orphan. He had stolen some stationery worth AU$90 and broken some windows, causing AU$50 worth of damage. At the time, his grandmother, who looked after him, was ill in hospital.

For these offences, Johnno was sentenced to 28 days, taken to Darwin 800 kilometres (500 miles) from his home, and jailed in the Don Dale Correctional Centre. Five days before his release date, Johnno hanged himself with a bed sheet.

The issue has not gone away. In the Northern Territory, another round of harsh mandatory sentencing laws were introduced in 2013. Australia's prisons still have a rising number of deaths in custody, many of them caused by ill health.

> "(Mandatory sentencing laws)... have been a primary cause of one of the highest suicide rates in the world, among young Aborigines."
>
> **Australian journalist John Pilger.**

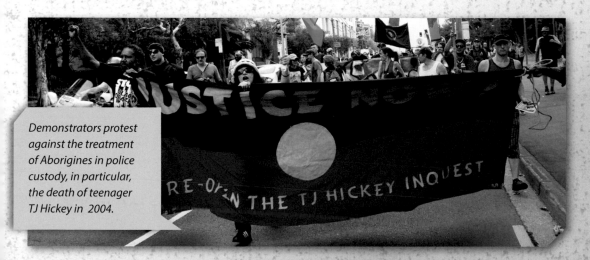

Demonstrators protest against the treatment of Aborigines in police custody, in particular, the death of teenager TJ Hickey in 2004.

> 'The millions of dollars we spend on locking people up, we should be spending on improving the lives of Aboriginal people.'
>
> **Jonathon Hunyor, Northern Australian Aboriginal Justice Association (NAAJA), 2013.**

HOW CAN WE TACKLE RACISM?

Institutional racism can be tackled by reversing the process of racial discrimination. This will ensure that people from ethnic minorities are represented across a wide range of employment. This policy is called positive discrimination.

Values and rules

Most cities are multicultural. They are home to people from various ethnic backgrounds who have different faiths and speak different languages. Is the best way of diffusing tensions to celebrate this diversity and campaign for equality of these communities? This policy is called multiculturalism. Or does a multicultural approach actually create social division? Is it better to have policies that encourage ethnic communities to merge with the majority under a single set of values?

Who stands for law and order?

Racists often claim that they stand for law and order, saying that ethnic groups should be 'sent back to where they came

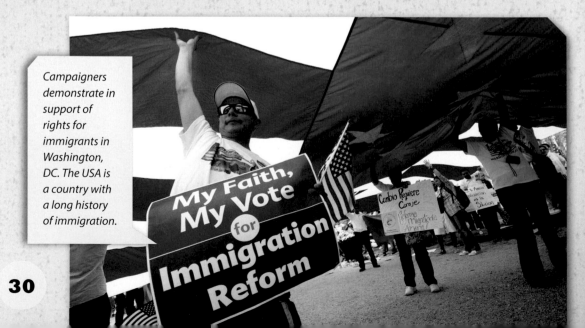

Campaigners demonstrate in support of rights for immigrants in Washington, DC. The USA is a country with a long history of immigration.

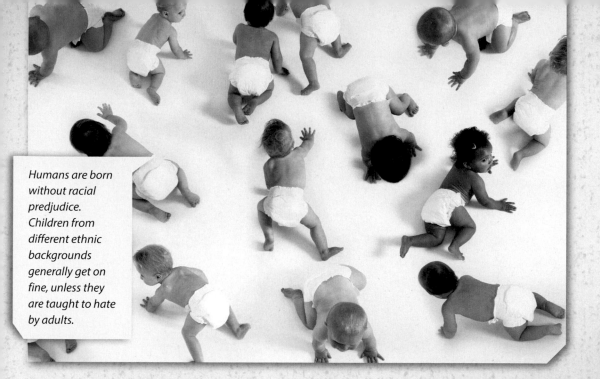

Humans are born without racial predjudice. Children from different ethnic backgrounds generally get on fine, unless they are taught to hate by adults.

from'. They ignore the fact that many members of those communities were born in the country. History is irreversible. The world is made up of migrants.

Racist policies do not support law and order. Nations that depend on slavery, apartheid or injustice are unsustainable economically, morally and politically, and risk collapse. Is the same true of an economy that does not treat people around the world equally? Campaigners for a unified global community argue for a balanced world economy that treats all regions fairly and does not just favour the richer Western nations over less well-developed African ones.

DEBATE

Is positive discrimination the best way to tackle institutional racism?

YES
Filling an agreed quota of positions with a certain number of people from ethnic minorities redresses the balance and challenges deeply entrenched racial stereotypes.

NO
It infringes the basic right of equal opportunities for all. The only measure for recruitment should be finding the best person for the job. That benefits everybody.

THE ROLE OF THE MEDIA

People who have little personal experience of crime, let alone crime associated with race, find out about these issues in the news. Media sources are influential, shaping the impressions and opinions of the public. Politicians follow public opinion in their search for votes and tailor their policies accordingly.

Media hype

Some newspapers and broadcast media offer valuable insights or investigations into issues of race and crime, but many prefer a sensationalist treatment of the news. Stories about crime or terrorism sell newspapers, and are featured so often that they can give misleading impressions – that crime is rising, for example. Who are most likely to be the victims of muggers – vulnerable, old ladies? No, young people, but you would not think so from press reporting. Even if journalists avoid the vocabulary of race hatred in their reporting, they may still contribute to a climate of fear with their use of emotive language. They talk about a crime 'wave', a 'flood' or a 'tide' of immigrants: all words that suggest something is threatening, overwhelming or dangerous.

'Four out of five British people believe that the media's portrayal of ethnic minorities promotes racism.'

Rob Berkeley, director Runnymede Trust, a race equality think tank.

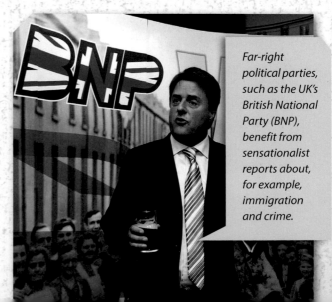

Far-right political parties, such as the UK's British National Party (BNP), benefit from sensationalist reports about, for example, immigration and crime.

Stereotyping

Positive news coverage of ethnic minorities may be limited to familiar areas, such as entertainment, music or sport. Crime reports are often framed in terms of race, without going into other issues that may be just as relevant. Often, asylum seekers are not presented as refugees desperately fleeing war or persecution in their own land, but as alien scroungers or criminals – an imposition on the state.

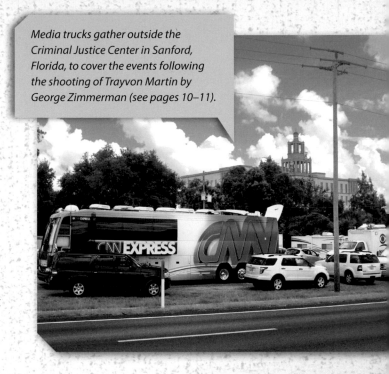

Media trucks gather outside the Criminal Justice Center in Sanford, Florida, to cover the events following the shooting of Trayvon Martin by George Zimmerman (see pages 10–11).

Why Two White Kids Are a Senseless Tragedy but an Arab American Is Terrorism

Heading to an article by Brian Ross in *The Huffington Post*, 2009.

PUBLIC PERCEPTION

Could it be that warped media coverage of race and crime issues misleads the public? A poll carried out in the UK in 2013 showed that people wrongly estimated key statistics:

Topic	True figure	Public estimate
What percentage of the population is Black or Asian?	11 per cent	30 per cent
What percentage of the population are recent immigrants?	13 per cent	30 per cent
58 per cent of those polled do not believe crime rates are falling.	In 2012, crime rates were 53 per cent lower than in 1995.	

FRANCE AND KOSOVO, 2013

In recent years, many Roma people have fled to western Europe. In 2013, French Interior Minister Manuel Valls declared that Roma people were 'incompatible with the French way of life'. He ordered the eviction of about 10,000 Roma from temporary camps in France.

NEWS FLASH

Location: Doubs, France, and Mitrovica, Kosovo
Date: 9 October 2013
Incident: Expulsion of Roma family
Issues: Deportation and the law
Victim: Leonarda Dibrani (aged 15, left)
Outcome: Deportation

Following their expulsion from France, Leonarda and her family returned to Kosovo.

The girl on the bus

The topic of illegal immigration became one of the biggest stories in the French media in 2013. That October, a Roma family named Dibrani, living in eastern France, finally lost its battle to stay in the country where they had been living for five years. When the police came for them, 15-year-old Leonarda Dibrani was away on a school trip. The police tracked her down and took her off the bus in full view of her friends. The family was deported to

Kosovo. Her father Reshat had said that was where they came from, but in fact Leonarda had been born in Italy.

Supporters and opponents

Many people were upset by the uncivilised way the teenager had been dealt with. School children and students protested on the streets against the seizure of Leonarda Dibrani.

However, other people applauded any crackdown on illegal migrants. The French government insisted it had behaved humanely. It offered to take Leonarda back to be reassessed, but not the rest of her family. She declined the offer. Later, an official report by the government backed the deportation of the Dibrani family as legitimate.

'**There are bad refugees in France who get papers easily – we didn't do anything bad. They did it to us because we are Roma. We would be treated differently if our skin was a different colour.**'

Reshat Dibrani, Leonarda's father.

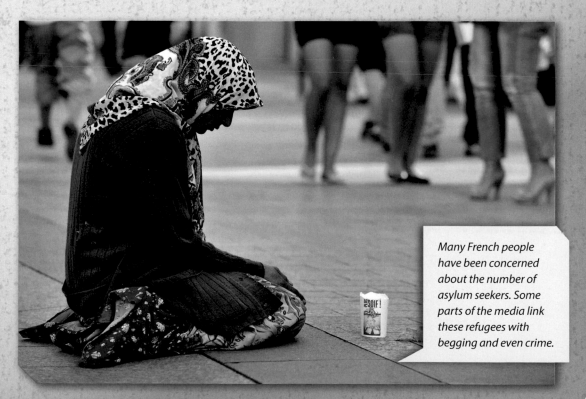

Many French people have been concerned about the number of asylum seekers. Some parts of the media link these refugees with begging and even crime.

CAN THE MEDIA BE RACIST?

How the newspapers, television and radio report the news can have an effect on how we view the people involved. But it is not just factual broadcasting that can have an influence – how ethnic groups are portrayed in fictional settings and general entertainment can also have profound effects.

Tunnel vision TV

Do the media offer a limited input of opinion when they cover race and crime issues? The views of senior police officers, judges, media chiefs and politicians all tend to feed into each other and set the agenda. This closed circuit of top people may influence policy yet it excludes voices from the street, or victims of crime. Does limited reporting of overseas news also encourage stereotyping and xenophobia? News from Africa or Asia tends to focus on famine, natural disasters and war or terrorism, but ignores the many positive stories about everyday life and culture. This helps build up an impression that 'other' people are trouble, rather than people who can contribute and take part.

Local children go about their everyday lives in Zambia, Africa. Despite media stories of war and famine from Africa, millions of people on the continent lead normal lives.

Romancing the gun culture

The image of ethnic minorities presented in on-screen crime drama and in computer games is important, as it may have an affect on young people's self-image and aspirations. Gun-toting gangsters may be stereotyped as cool black dudes or even as Italian-American mafiosi, but their portrayal is often divorced from reality. On the other hand, a 'politically correct' drama that tries to avoid offence often seems to be even more contrived and unrealistic. The television crime series that work best are those that seek to root themselves firmly in truth and genuine understanding, such as the US television series *The Wire* (2002–2008).

Gangsta rap

The medium of popular music has been associated with race and with crime since the 1900s. Over many decades, drug taking has been associated with jazz, rock, punk and reggae music, and hip hop and gangsta rap been accused of promoting guns, knives, drug abuse, violence and rape as well as aggression towards women and gays. Has this music encouraged black teenagers especially to take up gang culture? Or is it just reflecting the poorer urban society in which it has its roots? A career in music may have brought some black artists great wealth, but has the industry distorted the black urban experience for profit?

US rapper 50 Cent has been accused of promoting gun violence through his lyrics and music. He denies this accusation, saying that he draws on his own experience to create 'art imitating life'.

'People of colour have a constant frustration of not being represented, or being misrepresented, and these images go around the world.'

African-American film maker Spike Lee.

JUSTICE FOR ALL

The principles of racial equality have inspired an international framework of law. The Universal Declaration of Human Rights (UDHR) was drawn up by the United Nations (UN) in 1948. This was the first global expression of the essential qualities needed by all humans, of whatever ethnicity, to lead a decent life.

Without distinction of any kind...

Article after article of the UDHR tackles head-on the issues of racism and justice. It affirms the equality of all people, in society and before the law. Later international conventions addressed aspects of racism in more detail – genocide, treatment of refugees, discrimination in employment, civil rights, rights of indigenous and tribal peoples, of migrant workers. Other regional conventions also define many of these rights, such as the European Convention on Human Rights (ECHR), enacted in 1953 by members of the Council of Europe (a separate organisation from the EU).

The UN defines apartheid as 'Inhuman acts committed for the purpose of establishing and maintaining domination by one racial group of persons over any other racial group of persons and systematically oppressing them.'

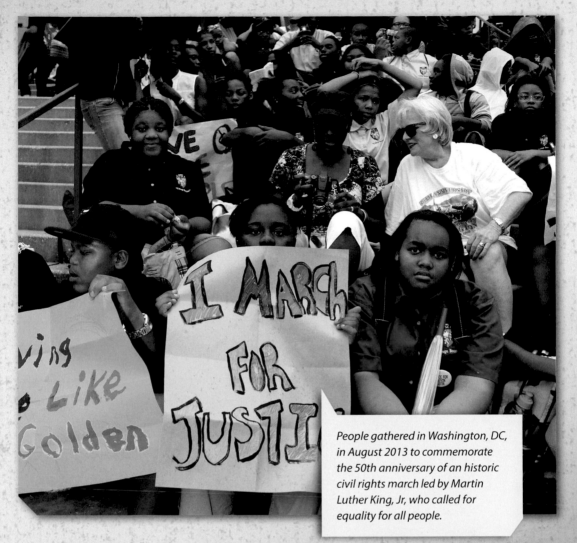

People gathered in Washington, DC, in August 2013 to commemorate the 50th anniversary of an historic civil rights march led by Martin Luther King, Jr, who called for equality for all people.

The rule of law

Even though the desire to abolish slavery has endured since the 1800s, national laws vary hugely from one country or state to another. This has made change difficult to achieve, as campaign groups have to deal with different legislation from one country to the next. Milestones were reached in the 1960s, after civil rights campaigns in the United States and the first anti-racist legislation in Europe. Britain's Equality Act of 2010 aimed to bring together various earlier laws under one heading. It requires public bodies to plan for equality in employment, services and budgeting and to take positive action to increase diversity.

Stand up for your rights!

Even today, it often takes great courage for an individual to blow the whistle on racist crime or abuse, to stand up to the police or the company they work for, or complain about racist bullying in schools or the workplace.

LAMPEDUSA, ITALY, 2013

Lampedusa is an island in the Mediterranean Sea. It is the southernmost part of Italy, just 130 kilometres (80 miles) from the coast of Tunisia. In recent years, it has attracted thousands of illegal migrants, all in search of a better life in Europe. They are fleeing war, terrorism, persecution or grinding poverty.

NEWS FLASH

Location: Island of Lampedusa, Italy
Date: 3 October 2013
Incident: Shipwreck of illegal migrants
Issues: People smuggling, border controls, refugees
Victims: Migrants from Eritrea and Somalia
Outcome: 364 deaths

An African migrant and her son watch a memorial service for hundreds of migrants in the Lampedusa disaster.

The people smugglers

Refugees pay extortionate sums of money as they are passed along chains of criminal gangs, who guide them through deserts and smuggle them across borders. On the way, the refugees may be robbed, raped, beaten up or taken hostage.

A tragedy at sea

On 3 October 2013, a boat travelling from the Libyan port of Misrata suffered engine failure. The passengers lit a fire to attract the attention of the coastguards, but it spread and the passengers scrambled to the other side of the boat, which capsized.

Most of the people on board were originally from Eritrea or Somalia, and could not swim. It is thought that more than 360 people drowned, including women and small children. Local fishing boats and helicopters searched for survivors, but only about 200 bodies were found. Such incidents were not uncommon on Lampedusa and the islanders, shocked and saddened by the latest tragedy, did all they could to help.

The plight of asylum seekers

An insecure world, a global economy and economic injustice have placed migrants and asylum seekers at the centre of a political storm across Europe. Those who do manage to get in may find themselves treated like the worst criminals, derided in the media, subjected to racist abuse or even attacked on the streets.

Who were the worst criminals in the Lampedusa tragedy? The illegal migrants who drowned in search of a dream? The warmongers and racketeers who forced them to flee their homes? The ruthless gangs of people smugglers? The world economic system? Or the politicians who decide border policy and access to the European Union?

'We have fallen into a globalisation of indifference.'

Pope Francis, Head of the Roman Catholic Church, speaking in Lampedusa, 2013.

CAN THERE EVER BE JUSTICE?

How can the biggest race crimes, such as apartheid or genocide, ever be resolved? Can there ever be meaningful justice for the ruining of so many lives, or for the systematic murder of thousands or millions in the name of 'ethnic cleansing' or 'racial purity'?

Trials and tribunals

Sometimes, perpetrators do finally appear in court. In 1945, leading Nazis responsible for the murder of millions of Jews in the Holocaust were tried at Nuremberg in Germany. After the Yugoslav Wars of 1991–99, a number of Serbians were tried at a special UN tribunal at The Hague, in the Netherlands. They were charged with severe racist crimes, such as ethnic cleansing.

International prosecutions

Since 2002, crimes against humanity may be tried at the International Criminal Court (ICC) at The Hague. Many ICC cases have investigated ethnic crimes in Africa, such as those alleged to have taken place in Darfur from 2003. Some nations have attacked the ICC for prosecuting African cases and ignoring crimes committed by Western leaders. Others have criticised the United States and Israel for not signing up to the ICC.

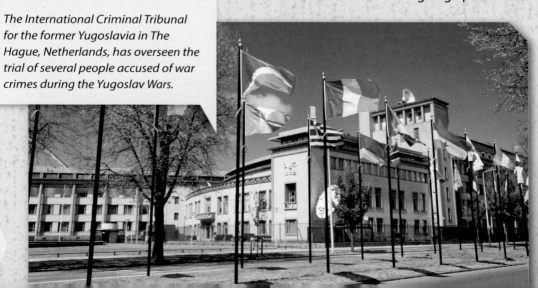

The International Criminal Tribunal for the former Yugoslavia in The Hague, Netherlands, has overseen the trial of several people accused of war crimes during the Yugoslav Wars.

Reconciling difference

Restorative justice is another kind of process that aims to heal wounds and move forward. It restores the dignity of victims and sometimes offers an amnesty to the offenders rather than prosecuting and punishing them on points of law. From 1996, South Africa's Truth and Reconciliation Commission (TRC) attempted to redress the crimes of apartheid. It may have been a sensible solution to unify a country that was undergoing transition, but it was criticised as being no substitute for criminal justice. Similar commissions have been held in many other nations, too.

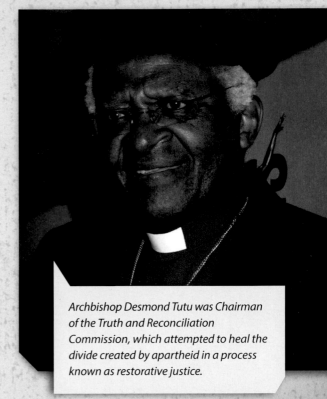

Archbishop Desmond Tutu was Chairman of the Truth and Reconciliation Commission, which attempted to heal the divide created by apartheid in a process known as restorative justice.

DEBATE

Can restorative justice remedy a crime against humanity?

YES

It can break a deadlock and end a cycle of vengeance between communities.

NO

If it lets racists and criminals off the hook, it cannot really be called justice.

'When we see others as the enemy, we risk becoming what we hate. When we oppress others, we end up oppressing ourselves. All of our humanity is dependent upon recognizing the humanity in others.'

Archbishop Desmond Tutu, chair of South Africa's Truth and Reconciliation Commission.

STANDING TOGETHER

There is a popular saying that 'there is only one race, the human race'. If that has some truth in it, then it follows that it is people's ideas of race, rather than race itself, which so often divides the world.

Who holds the power?

Of course racist ideals or criminal intent might be held by a human being of any ethnic group. However, the consequence of those ideas depends on who holds the power. At street level, as in the school playground, power lies with the majority who can make life miserable for the minority. An imbalance of power in society can create a criminal underclass or a ghetto. Top-heavy political, social, military or economic power can create laws of segregation, apartheid government or acts of genocide. Underlying that power is desperation, anxiety and fear of change.

Who gets the jobs?

Equality means more than legislation. It cannot be created without economic opportunity. Black youths in the poorer districts of big cities deserve an alternative to the gang culture of guns and knives – they need genuine, rewarding jobs. Racists who blame the high rate of young black offenders on 'race' rather than on economic and social conditions often ignore the fact that it is usually black community activists who have been at the forefront of campaigning against gun and knife crime and building trust between law enforcers, such as the police, and the community.

The way forward

One person who challenged oppressive, racist power was Nelson Mandela (1918–2013). Mandela broke the law to take on

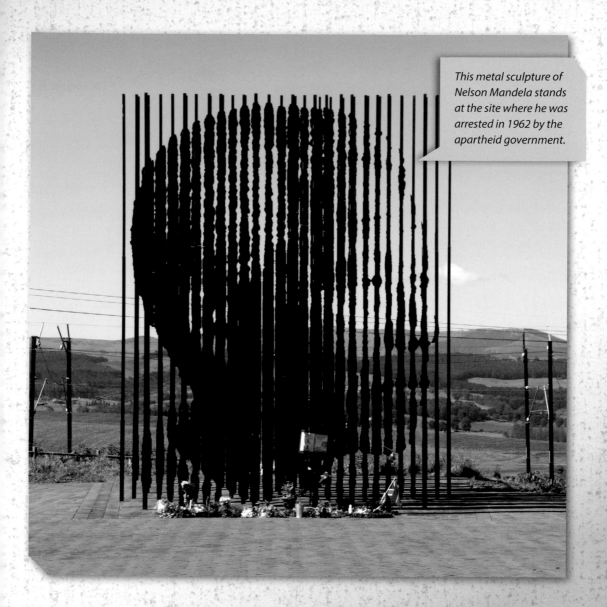

This metal sculpture of Nelson Mandela stands at the site where he was arrested in 1962 by the apartheid government.

South Africa's apartheid government. He served 27 years in jail, but in the end he defeated institutional racism with a vision of equality, education and economic justice for all.

Everyone, whatever their colour or community, can work together to bring about that. They simply need to defuse the fear and rage that lie inside some people to defeat the crime.

'We are fighting for a society where people will cease thinking in terms of colour.'

Nelson Mandela.

GLOSSARY

adaptation
When something adjusts or changes in order to fit in with new circumstances or environments.

apartheid
A legal and political system that classifies and segregates people according to race or colour. South Africa was governed under an apartheid system between 1948 and 1994.

assumption
Something that is taken for granted and believed to be true, even though it may be false or misleading.

asylum seeker
Someone seeking refuge in another country. Asylum seekers are usually fleeing political persecution, famine or poverty.

bigotry
Beliefs or opinions that are based on intolerance or prejudice and shape people's thoughts and actions against other groups or individuals.

condemnation
Negative criticism of something. It also means writing something off as useless or irrelevant.

custom
A way of behaving, a tradition or a practice that is carried out in a particular country or region.

deportation
Removing a person or a group of individuals from a country by force and sending them to another country.

economic rivalry
When different people compete for jobs or money.

eradication
To wipe out or destroy.

ethnic cleansing
The removal of communities from a region by force, on the grounds of their ethnic background or religious beliefs. They may be deported, intimidated, attacked or murdered.

evolution
A gradual process of formation, development or change that usually occurs in response to changing environmental conditions.

fascist
A supporter of an aggressive form of government that is usually nationalistic and authoritarian.

Holocaust

The mass-murder (genocide) carried out in Europe by Nazi Germany during the 1930s and 40s. The victims included about six million Jews, as well as Roma and other eastern Europeans.

institutional racism

Racist attitudes or inequality practised within companies, governments or public bodies, such as schools, colleges or police forces.

Ku Klux Klan

The name given to various, often violent and corrupt, racist organisations, which have existed in the USA since the nineteenth century. They are known for wearing long white robes with pointed hoods and setting light to crosses to intimidate people.

multiculturalism

A diversity of cultural attitudes or customs within the same society.

neighbourhood watch

An organisation in which local citizens keep an eye on a neighbourhood. They report burglary, vandalism or other criminal activities to the police with the aim of reducing crime in their neighbourhood.

non-premeditated murder

A killing that has not been planned in advance.

nonsensical

When something makes no sense.

prejudice

A preconceived negative attitude that prevents fair judgement and leads to the unfair treatment of other people.

racial profiling

Focusing on the racial background of suspects in law enforcement, rather than other aspects, such as social background.

Roma

One of several names used to describe the ethnic group also known as Romanies or Gypsies.

scapegoat

A person or group which is assigned the blame for the faults of others.

stereotyping

Having a simplified or generalised view that does not take individual characteristics into account.

supremacist

Someone who believes that one ethnic group is superior to all others.

xenophobia

An irrational fear or hatred of strangers or foreigners.

INDEX

BEHIND THE NEWS

978-0-7502-8252-9

978-0-7502-8255-0

978-0-7502-8254-3

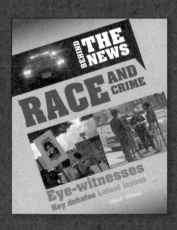

978-0-7502-8256-7

978-0-7502-8253-6

978-0-7502-8257-4

WAYLAND